Dreamscapes

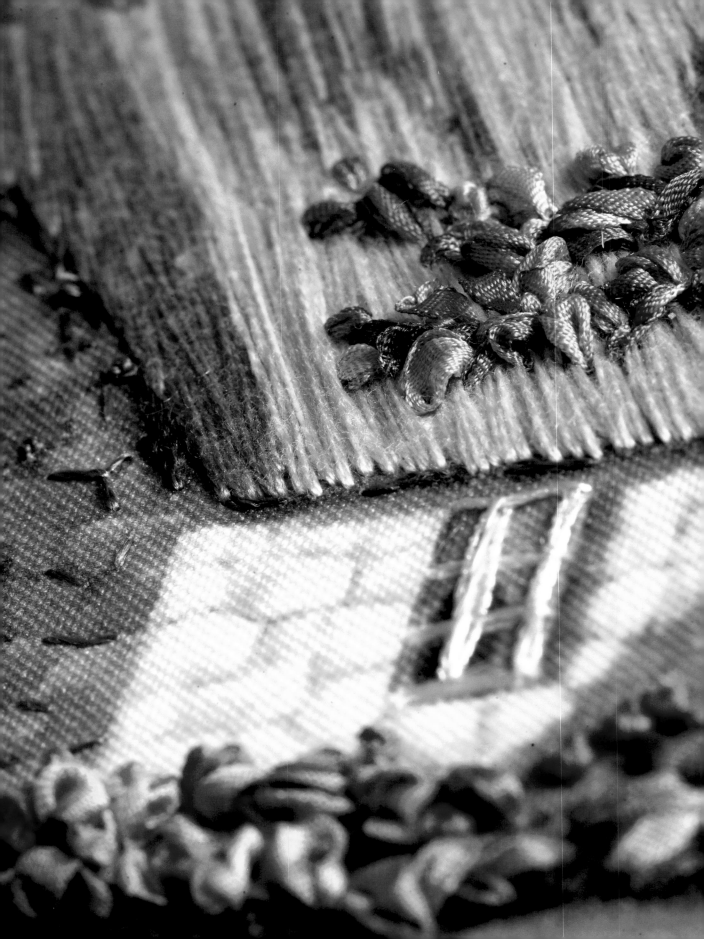

Dreamscapes

in ribbon embroidery and stumpwork

Di van Niekerk

SEARCH PRESS

This book is dedicated to my twin, Deon.
You are always nearby.

First published in Great Britain in 2006
Search Press Limited
Wellwood, North Farm Road
Tunbridge Wells
Kent TN2 3DR

Originally published in South Africa by
Metz Press, 1 Cameronians Ave, Welgemoed 7530

ISBN: 1-84448-160-3

First published in 2005
Copyright in publication © Metz Press, Di van Niekerk 2005
Embroidered designs copyright © Di van Niekerk
Original artwork copyright as specified

PUBLISHER & EDITOR WILSIA METZ
PHOTOGRAPHER IVAN NAUDÉ
DESIGN AND LAY-OUT LINDIE METZ
ILLUSTRATIONS ANDRÉ PLANT
REPRODUCTION CAPE IMAGING BUREAU, CAPE TOWN

PRINTED AND BOUND IN SINGAPORE BY TIEN WAH PRESS (PTE) LTD

Contents

Acknowledgements

To Serena Shaw of *Pucketty farm*, thank you for starting out on this journey with me – you are simply the best!

To Via Laurie of *Chameleon Threads*, thank you for your beautiful threads, their glorious colours and textures, and for the new colours you made for this book. It has been such a pleasure working with you – you have an amazing talent! To Renn van Niekerk and my incredible team in Newlands: Sylvia Balintulo, Beauty Diko, Tamara Nonxuba and Veronica Ntsokwana and the others, thanks for helping me make our Di van Niekerk's Hand Painted range of ribbons for this book – I know how hard everyone worked to create the extra quiet time I needed for this book.

To Wilsia Metz of Metz Press, my editor and publisher – an amazing person who makes everything seem just so easy. It is a privilege to have you as a friend and I thank you. I know how hard you work to show South African talent to the world and for that we are all grateful. To Rina Auret thank you for translating this book into Afrikaans – it is good to know I am in the hands of an expert. To Ivan Naudé, thank you for your incredible photography. Your gentle patience belies a rare talent. To Alinda Metz, thank you for your stylish layout and for all the new concepts – you have a remarkable skill!

To Alveda Nickel, Zulfah Joshua, Christine Booysen and Levouna Abrahams at the Waterfront and Bellville shops, thanks for your loyal support and enthusiasm. To Liz Sheffield thanks for all your help, for embroidering the beautiful roof and trees for the Swan Cottage in this book, for helping with my classes – I could not have done it without you! To all my students, thank you for your patience in my absence while I was writing this book. To Emma Kriegler, my right hand, thank you for all your help. To Ingrid Herzfeld, thank you. To Felicia Lemmer and her team: Elba Kruger, Annatjie Klingbiel and Santonette Roos, thank you for your help and all those involved with the new designs – I am very grateful for your talent.

To Riana van der Merwe of *Threads & Crafts*, on behalf of all embroiderers, thank you for your astonishing talent for sharing South African crafts with everyone who reads your wonderful magazine. To Ria of *Threads for Africa*, thank you for your beautiful wools and Martini Nel of *NeedleArts* for your lovely threads. To Julie Ellis of *Gumnut Yarns* –thank you for your amazing silk threads – I really enjoy working with them.

To Toody Mouton, thank you for helping with the proof reading of this book and for your gorgeous *Norbillie* threads and fibres – may you go from strength to strength. To all the needlecraft shops and studios, I thank you for your support and hard work helping embroiderers choose their designs and ribbons and for teaching them how to do it. And last but not least, thank you to my family (and all the animals) for their quiet patience and support.

Introduction

Ribbon or Rococo embroidery is probably the easiest and most forgiving of all the different forms of embroidery and is especially suited to the beginner to this art form. It is almost impossible to make a mistake with ribbon and with minimal effort a dramatic and beautiful result can be obtained in no time at all. Anyone who can thread a needle can do silk ribbon embroidery and I really do mean that! Ribbon fills up detail very quickly and creates an exciting three-dimensional effect which is impossible to achieve with embroidery threads alone.

The use of silk ribbon eliminates the need for highly elaborate, time consuming embroidery stitches. It is quick and easy – ideal for our hectic schedules where the desire exists for a creative hobby, although leisure time is so limited! It is often said that a lot of patience is required for embroidery, but my reply is that patience is needed only for boring, repetitive work and this certainly does not apply to ribbon embroidery!

The original artwork for the designs included in this book were painted by various gifted artists. The printed designs on pure cotton are available from Di van Niekerk and needlecraft outlets worldwide (details on page 21) if you do not want to go to the trouble of transferring the images onto fabric. The flowers and foliage are the correct size and shape for ribbon and you will be pleasantly surprised at how quick and easy it is to create a beautiful picture. Just fill in the details on the printed cloth that you wish to enhance and leave some painted sections unadorned to complement your work. You will be combining ribbon with other embroidery threads such as silk, cotton, rayon and perlé, and pleasing results can be obtained by using knitting yarns or any other texture you wish to add to your design. This is a good opportunity to use up all those threads and wools you have hoarded over the years! There are very few rules here – anything goes as long as you are enjoying yourself!

It takes time and practice to develop fine embroidery skills. Don't be deterred by imperfections – the paintings are detailed enough to hide most 'mistakes'. Do not unpick unless absolutely necessary – just cover what you don't like with more ribbon or thread. This adds texture to the design. Remember that the charm of your work may well be lost if it looks too perfect!

When you look at some of the detail photographs where the smooth silk ribbon appears to be textured, bear in mind that these are top quality close-up pictures picking up the finest detail of woven silk fibres. The actual ribbon is silky smooth.

The designs in this book may appear very detailed, but only the most basic stitches are used. This is why they are especially suited to the beginner to this art form. By enhancing these images with a variety of colours, textures, ribbons and threads, you will achieve amazing results. If you are a more experienced needle-crafter you will enjoy the challenge of adding your own more advanced stitches in order to create your own unique masterpiece. I have no doubt that your creations will become much talked about family treasures.

Enjoy yourself!

How to use this book

Each embroidered design is depicted in full colour and there are clear, detailed close-up pictures, as well as step-by-step photographs where necessary, to guide you as you work. The stitches and textures shown are merely suggestions, though, and you can choose from a wide range of stitches in the stitch glossary.

In the 'old' days (only a few years ago!) embroiderers used to build designs from a blank canvas – only black and white drawings were used and extensive, time consuming stitching was necessary to build detail. Now, working on images in full colour, all we need to do is embroider a few (or all) of the flowers and background detail according to the time and expertise we have. There is no need for highly elaborate stitches to build texture as the colours of the design itself contribute a lot to add depth and interest.

I will explain the different methods used to create perspective in your design, and there are lots of hints throughout to guide you with the new ideas I used in this book.

The designs are suitable for framed pictures – see framing your design on page 18.

TRANSFERRING THE IMAGES ONTO FABRIC

The ready to use printed designs on good quality pure cotton are available from Di van Niekerk and needlecraft outlets worldwide. A word of caution, though – be careful of imitations! There are a few copy shops who simply copy second generation prints and transfer these onto inferior quality fabrics sold by charlatans with no regard for copyright implications. To avoid this potentially costly error, ensure that the packaging states it is a *Dreamscapes* product.

The images provided on pages 106–109 of this book are for personal use only. If you prefer not to purchase the printed cloths from us, ask your copy shop to enlarge the image to the size indicated at the beginning of each project and copy it onto a 60 x 60 cm square of pure cotton.

COLOUR

Tone is the intensity of colour – light or dark. A tint is made by adding white to a primary or secondary colour. A shade is made by adding black. Bear this in mind when choosing and using colours for the designs.

Darker tones normally recede as they absorb light and lighter tones advance. Use vibrant warm colours such as orange and red in the medium or near distance (foreground). Muted, cooler colours such as pale green or blue need to be in the far distance to create depth or distance in a design.

Please feel free to change any of the colours in the design. If you would like to use more vibrant colours instead of any paler ones on the design, by all means do. Just remember to use some of the same brighter colours somewhere else in the design for balance.

TEXTURE

Texture in a design creates interest. Ribbons and threads are naturally textural – the smoothness of silk contrasts well with rougher threads and wool. By adding bold three-dimensional effects such as a high relief pot or shape, you create light and shade in your work. Texture in these designs is achieved by mixing ribbons and thread and adding relief by means of Trapunto. The smooth, pure-silk ribbons reflect light and are therefore more prominent in the design; the finer, duller threads absorb light and are less noticeable in the design. How you combine the different textures plays an important role in your design. Different ribbon widths and thickness of thread, too, play an important part.

Materials required

In addition to a printed design on pure cotton, you will need needles, ribbons, threads, embroidery and quilting hoops, and other miscellaneous items depending on the actual design you embroider.

RIBBONS

There is an amazing assortment of ribbons, in a wide array of colours, widths and textures. These are available from needlecraft suppliers and speciality mail-order companies worldwide. The ribbons used in this book are from Di van Niekerk's Hand Painted range of ribbons.

Different fibres are used in the manufacturing process ranging from pure silk to velvets and sheer organdies. Soft and pliable pure silk ribbon is without a doubt the best ribbon to use if you want to create a true reflection of nature's plants. I find the hand-painted, multicoloured or variegated ribbon the most suitable for creative embroidery as the sub-tlety of varying colours and changing shades as you stitch help to create a more authentic effect consistent with real flowers and leaves in nature. The plain or solid silk ribbons can be used in combination with these to cut down on costs, but I do find that designs tend to be flat and lack atmosphere and depth if only the plain colours are used.

Other ribbons available on the market are sheer organza ribbons. The Di v N hand-painted, variegated 6 mm and 15 mm organza ribbon is the best kind to use for the images in this book. Use it in the near distance or foreground of the design as this is a bulky ribbon which makes large stitches.

Choosing different widths of ribbon

I have included the widths of the ribbons I used in each project. As a guide to choice of ribbon width, look at the design and note the size of the flowers and leaves. Bigger flowers and leaves require wider ribbons. Tiny flowers and leaves will look best made

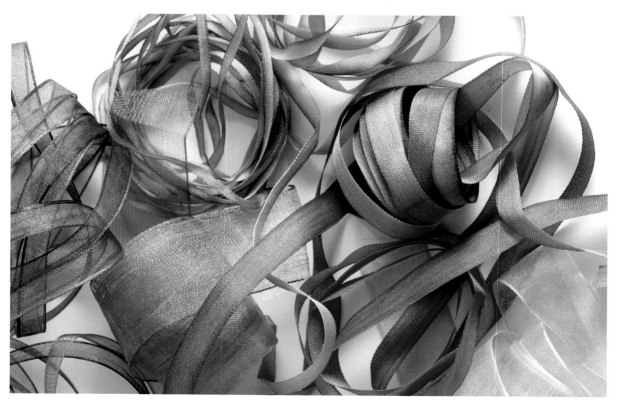

in 2 mm ribbon. Always try to be aware of the proportions in the design as it does help to create a better picture. Refer to the completed design in the book and note the size of the flowers compared to the adjoining ones. If your flowers are too large in comparison, you may have trouble creating the correct balance and depth.

Depending on the stitch you are using, the ribbon should cover all or most of the painted detail without being so large that it is out of proportion.

Working with ribbon

Silk ribbon embroidery is surprisingly easy to master. Basically ribbon is worked just like any other thread or yarn except that it is much softer and more fragile. It is vital that you use a large chenille needle with a large eye (see Needles on page 15) so that you will make a big enough hole in the fabric to prevent the ribbon from snagging and folding. Use these guidelines when working with ribbon:

- Ribbon needs to be worked flat for most of the stitches.
- Use only short lengths of ribbon – 30 cm (12 in) – as longer pieces will fray if pulled through the fabric too often. It is also difficult to work with ribbon that is too long and the quality of the stitch is affected.
- To start, thread the needle and pierce the end that has just been threaded. Pull the long tail to tighten the knot.
- To begin stitching, you have several options:
 - Leave a small tail at the back of the work and as you make your first or second stitch, pierce the tail to attach it to the fabric; or
 - Anchor the tail with embroidery thread; or
 - Knot the 2 and 4 mm ribbons as you would a thread. The texture of the design is busy enough to hide the bulkiness of the knot.
- To finish, you also have several options:
 - Leave a tail 1–2 cm (½ in) long, at the back of the work and secure with 1 or 2 strands of embroidery thread – use adjacent stitches when anchoring the tail; or
 - Catch the tail when you start your next thread; or

 - Weave the ribbon in and out of adjacent stitches at the back.
- Use your left (or right if you're left handed) thumb to hold the ribbon flat as you pull it through to the back. Only let go once the stitch is almost completed. This prevents the ribbon from twisting. Alternatively use the eye of another needle and gently (without snagging) hold the flat ribbon in place until you have pulled it through.
- Work with a gentle tension – ribbon needs to be handled gently. Keep stitches loose and unfolded. Allow it to spread easily to its full width on the fabric before starting the next stitch. If your tension is too tight or the needle too small, the ribbon folds up and the beautiful texture is lost. If you've pulled a stitch too tight in error, don't be deterred – simply make other stitches on top of it. This adds texture to the design!

Twisted ribbon

Some stitches look good if the ribbon twists as you stitch, for example:

- Woven spider-web roses
- Long straight stitches for leaves
- Some larger detached chains
- Large, loose ribbon stitches
- Twisted ribbon stitch
- Loose French knots
- Folded ribbon roses.

Form some of the stitches with flat ribbon and others with twisted ribbon for an interesting variation.

How much of a colour?

It is virtually impossible to specify how much ribbon you need to purchase for each design, as there are so many variables. Meterage (yardage) depends on what stitch you use, the width of the ribbon and how much of the selected colour you wish to use in the design.

Generally my students purchase individual colours of the Di v N 2 mm and 4 mm ribbon in lengths of 3 metres (yards) of and 7 mm ribbon in lengths of 2 metres (yards).

The wonderful quality about using the hand-painted or variegated ribbon and thread is that it is seldom that you have exactly the same dye-lot the next time you purchase more of the same colour. The shades are generally different allowing for even more depth and authenticity in your design. Flowers and leaves are never exactly the same shades in nature; why try to make them all the same in embroidery?

Hints

- *Always purchase more green than you think you will need as there is never enough to go around!*
- *When purchasing more of the same colour, why not look for a paler or darker shade that matches the previous one instead of purchasing exactly the same shade? This allows for light and shadow that adds more depth to the picture.*
- *If you find you are running out of a colour, don't embroider just one half of the section and wait till you purchase more. Rather spread your stitches out so that you can come back to fill in the gaps with another shade later for a more interesting effect.*

THREADS

There is a vast array of threads available, and I have used all kinds in this book. The brand names and colour codes have been included for easy reference. If you would like to substitute brands for others, simply refer to the pictures in this book to match the colours with your own. Just about any thread can be used as long as you can thread it through the needle and bring it through the fabric. Just check that these are colourfast before starting.

Stranded cotton

This thread is composed of six glossy, fine threads that are easily separated. It has a wonderful sheen and the colours can be combined to achieve a shaded effect.

Rayon

A regenerated, natural fibre, very smooth and shiny. This is a slippery thread and quite difficult to work with, but ideal for loose, wispy french knots and for making hair. It is usually composed of six strands that are separated to use as a single thread.

Perlé

A twisted thread with a pearly finish that cannot be divided. It is used as a single thread, with the no 8 (medium) and the no 12 (fine) the most suitable for the designs in this book.

A raised pattern is achieved with this thread and it is ideal for wooden poles or gates.

Pure silk

Made from the filament unwound from the cocoon of the cultivated silkworm, it has a lustrous, rich texture and is surprisingly easy to work with. The six-strand pure silks are divided into one or two strands for this book.

Like silk

A new and exciting multipurpose six-strand fine Rayon thread. It has the beautiful luster of Rayon and the thickness of stranded cotton. It can be used like stranded cotton perlé no 8 or even couched as a thin cord. To use as a stranded cotton cut to the

desired length and gently unwind a little and pull out as many strands as needed. To use as a perlé no 8 use six strands without unwinding it.

Metallic threads

These are available in one strand or six and add a touch of glamour to the design. They also highlight detail beautifully.

Use short lengths and a thicker needle when working with metallic threads. Gently pull through the fabric to avoid damaging the beautiful sheen.

Bouclé yarn and velvet cord

These are hand-dyed yarns, some with a knotted texture, some with a smooth, velvet-like appearance. Ideal for stems and branches, these yarns are couched in place as they are too thick to take to the back of the work.

Rayon chain-cord

This is created on the overlocker machine. Strands of Rayon and metallic threads are stitched together to create a chain-like texture.

French ribbon

A tubular yarn that can be hand-dyed for a shaded effect. To form the fuzzy stitches for the leaves of larger trees, hold the raw end between your thumb and index fingers and pull. The tube of wool will unravel into a frizzy texture. Cut short lengths and thread in a size 18 chenille needle. It is best used for loose seeding or tiny straight/stab stitches. The synthetic hand-dyed yarns may not be colourfast – take care to use this yarn only on the darker areas on your design.

CHOOSING THE THICKNESS OF THREAD

Once again, look at the design and use a thickness that will cover all or most of the painted detail. For very fine detail use one or two strands. For a rougher texture use three strands or perlé no 8 cotton or a bulkier yarn. For background detail in the far distance, finer and paler threads are generally used. For details in the middle distance, a medium thickness and colour are good and for near distance in the foreground, use thicker and brighter or darker threads.

Study the completed designs as these will teach you how to combine the various threads and ribbons as you embroider.

HOW MUCH THREAD?

With threads too, it is virtually impossible to predict how much of a colour you will need. Generally, purchasing one skein of each colour is sufficient. However, this depends very much on the stitches and how much of the same shade you intend to use in your design.

Hints

- *I have found that embroiderers tend to choose too dark a shade when selecting a colour. Try to choose one or even two shades lighter than that on the printed design.*
- *When choosing green for leaves, try to choose the same tone as the colour used for the flower. A pale flower needs a pale green. This will prevent the leaves from overshadowing the flower. A design where green is the most dominant colour is not as interesting as a design where flowers are the main feature. Refer to the completed design in the book to guide you with your choice of colour.*

NEEDLES

The right size needle is probably the most important choice you will need to make to ensure a successful product. Every beginner I meet is amazed at how large the needle must be for ribbon embroidery. It is vital that the needle makes a large enough hole in the fabric so that the ribbon is pulled through gently without snagging or damaging the silk. The ribbon can then spread evenly to form a soft, open stitch, instead of being all scrunched up after being pulled through too small a hole. The eye of the needle must also be long (large) enough for the ribbon to lie flat once threaded.

There are only five types of needles you need for this kind of embroidery.

Chenille

A sharp, pointed, thick needle with a large eye. Use size 18 (the largest) for the 7 mm ribbons and wool. In a mixed pack, the lower the number the thicker the needle. Size 20 or 22 is suitable for the 4 mm ribbon and size 24 for the 2 mm ribbon and perlé cotton.

Crewel (embroidery)

A sharp, fine needle with a long, large eye. Use sizes 5 to 7 for perlé cotton, thicker rayon and three to six strands of cotton, silk and thicker metallic threads, and sizes 8 to 10 for one or two strands of cotton, silk, fine rayon and metallic thread.

Straw (milliners)

A long, sharp needle with small eye. The eye is no wider than the shaft. This is the only needle to use for bullion knots. The wraps slip off the needle easily as the eye is not too wide. The finest no 9 straw needle is ideal for beading, the no 3 for the perlé threads.

Tapestry

A pointed, thick needle with a blunt tip and a large eye, in the same sizes as chenille needles. You may wish to use this needle for some of the surface stitches so that you don't snag the ribbon by mistake. Size 13 is ideal for wider ribbons.

Dolls'/soft sculpture needle

These are very long needles used for soft sculpture such as teddy bear or doll making. You would need a packet (usually two needles in a packet) for the closed picot stitch.

Hints

- *Change your needles regularly. They do tend to become blunt after continued use. I usually discard needles (safely!) after my third design. Once the needle feels sticky and has lost its shine, it is time for a new one.*
- *Never use the sharp end of the needle to try to adjust the ribbon stitches as this tears the ribbon. Always use the blunt edge of the needle or use a tapestry needle or any blunt instrument.*
- *Never store your needles in your embroidery piece. It damages the fabric – use a pin cushion or needle case.*

Backing fabric

You will need to use a backing fabric to stabilize and strengthen the printed design for embroidery. Use a thinner fabric such as polysilk, muslin or polycotton the same size as the background block. Both layers are inserted in the hoop at the same time.

Embroidery frame or hoop

I always use a large 18 inch quilting hoop when I start a design. Some embroiderers like to use smaller hoops but I find that if you can learn to fit all or most of the design into one large hoop, this will benefit you in two ways:

- You are able to see the entire design as you work, which helps with the choice of colour and texture. You need to see the bigger picture to choose the right shades and thread thickness.
- The hoop does not damage the ribbon stitches.

This is optional of course, so choose the size frame that suits you best.

There is a difference between embroidery hoops and quilting hoops. An embroidery hoop is a thinner hoop with a screw that needs to be tightened. A quilting hoop is much thicker and has a wing-nut that is tightened. Both hoops are suitable for embroidery but an advantage of a quilting hoop is that it is much sturdier and remains tightened for longer periods.

All the stab stitches (the stitches made through the fabric) are best embroidered on a hoop, especially satin stitch, French knots, stem-stitch filling, and long and short stitch. If the fabric is stretched on a hoop it prevents the design from puckering out of shape. Some of the surface stitches such as bullion knots, chain stitch and stem (some people like to do stem stitch on the hoop stab-stitch style) can be stitched out of the hoop. This is very much a personal choice – see what works for you.

To prevent the hoop from stretching and marking the fabric, cover the inner frame with strips of sheeting or bias first, to hold the fabric comfortably. Hold in place with a few stitches.

Every now and then pull the fabric taut in the hoop as you stitch. Tighten the screw as often as necessary to have a smooth, pucker free design. Roll up the four corners and pin or tack them in place outside the hoop so that the excess fabric does not hinder you while you are embroidering. This also prevents you from stitching the corners onto the back of the work by mistake!

Hints

- *Hoop stands are available that hold the hoop so that both hands are free to work. These are available from needlecraft shops.*
- *If you are embroidering a design that you prefer not to wash at all (these projects are not really suitable for washing as the stitches and fabric shapes will be spoiled) cut a block of white fabric the same size as your design. Mark a circle 3–4 cm (1–2 in) inside the hoop edge and cut along the drawn line. Lay this 'window' on top of your design and insert into the hoop with your design. Remove the protective layer once your embroidery has been completed. Use clear plastic or tissue paper if you do not have spare fabric.*
- *If you have chosen not to use the 'window' cloth on top of your work, remove or at least loosen your work from the hoop while you are not working on it as the hoop does tend to leave a dirty mark around the edge.*
- *Keep the embroidery stretched taut in the hoop as you work, to ensure a perfect tension. Tighten every time you start for a smooth finish.*

Miscellaneous items

I have not listed everything you may need as each design is different from the others. The following should be treated as a guide only – you do not need all the items for a successful project.

- Scissors: Small sharp embroidery scissors are a must.
- Pins, pincushion, needle case, tacking cotton (for rolling up corners).
- Needle threader.
- Needle grabber – small piece of rubber to help pull the needle through.
- Clean hands – keep wet-wipes or a damp cloth close by.
- Floss box – plastic compartmentalised box to store threads and thread bobbins to wind threads on, soft cardboard rolls to wind ribbon on.
- Large fabric bag or pillow case to store your embroidery.
- Leather or steel thimble (optional).
- Toy filling (for Trapunto).
- Daylight or good light with a comfortable chair and work table if possible. It is better to have all your ribbon and threads in front of you and it is always good to rest the hoop on the edge of the table as you work.
- New resolve to spend more time each week creating your masterpiece as embroidery is probably the best therapy there is for time out from our hectic lifestyles.

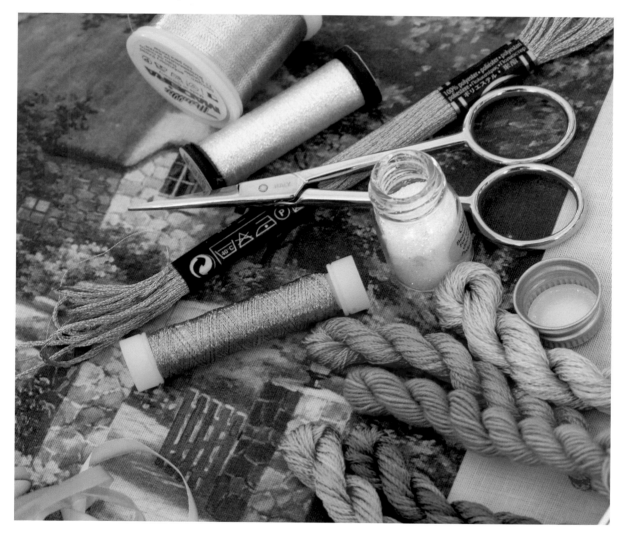

Framing your picture

Choosing the mounts and frame is not an easy task for most of us. There are so many to choose from. This is where a reputable framer who is experienced in framing embroideries can be of great help. The framer will also need to stretch the work well to achieve a good picture. The following points will guide you:

- Mounts must complement the picture. I strongly suggest that the mount and frame must match your design and not your décor. Don't choose colours that compete or clash. The embroidered picture should be more noticeable than the mount or the frame.

- Because of the depth of the design, you will need to have the glass raised so that none of the features are squashed. This is achieved by:
 - using several mounts in similar or complementary colours to lift the glass of the embroidery: or
 - using spacing blocks in-between the embroidery and mount or mount and glass so that it is raised off the design.

- The frame, too, should complement your work. Bear in mind that a heavy ornate frame may overpower your picture, but a simple cottage-style

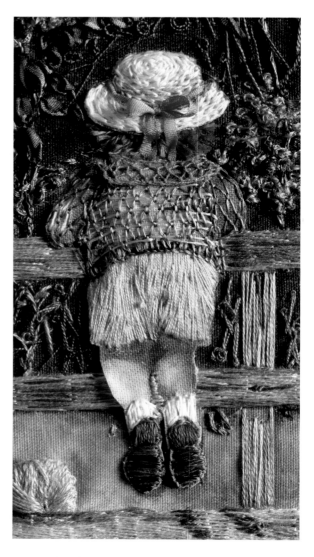

wooden frame may not do it justice either. Take your time when choosing a frame as the framed pictures will last a lifetime and become treasured family heirlooms!

Hint

Ordinary reflective (windowpane) glass is suggested for framing as the non-reflective glass hides a lot of detail and spoils the framed picture.

General hints and tips

- Use the best quality fabric, ribbons and threads you can afford to ensure an heirloom quality finished product.
- Never store embroidery in plastic. It will sweat and discolour as the fabric cannot breathe. Rather wrap it in an old sheet or pillowcase. Do not fold it; rather keep flat or gently rolled up or lay it flat in a drawer completely covered in acid free tissue paper. Store moth repellents separately.
- Handcrafted articles are best 'stored' on display in your home!
- Keep framed embroideries away from direct sunlight or harsh lights to prevent fading.
- Don't be deterred by imperfections in your work. The designs are detailed enough to hide most 'mistakes'. Don't unpick unless absolutely necessary, simply make more stitches on top of the ones you don't like – this adds texture to your design! The charm of your picture may be lost if it looks too perfect.

- As you work, you may find it easier to use a section of the hoop on the edge of the table or desk. There are hoop stands on the market that hold the hoop away from your lap or table. However, some of my students find the stands bulky and awkward to work with. Experiment with different ways and decide which one suits you best.
- When cutting ribbon, cut it at an angle so that a sharp point is formed making it easier to thread.
- Hold your embroidery hoop in front of a mirror to get a good idea of what the finished product will look like. Add extra embroidery stitches or silk ribbon until you are satisfied with the design.
- Choose colours in daylight – shades of colours tend to change with night-light, often quite dramatically.
- Garden flowers and foliage can be interpreted in so many different ways. Not one completed design looks exactly the same as another. Use the completed designs in this book as a guide only

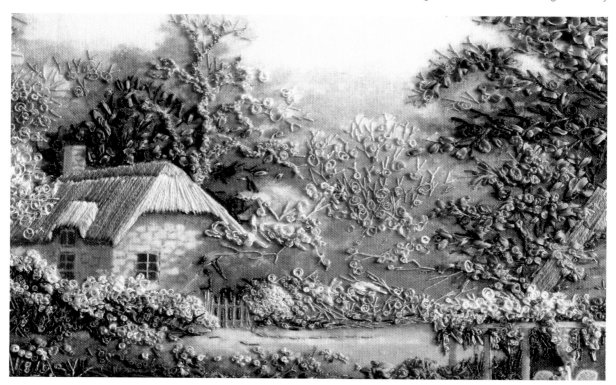

and feel free to make your own unique creation. Experiment with different colours and textures and use your own artistic licence.

- Botanical knowledge is not essential. Use the design as a guide and embroider the flowers and leaves according to your own taste and ability. For the mixed border plants I used a lot of puffed, loose ribbon stitches to create an illusion of flowers and leaves without a specific shape. If you would prefer to be more botanically correct, refer to a gardening encyclopaedia for exact shapes and colours of the different plants you wish to add to the design. There are sections in the designs that are only splashes of colour with no specific form. This is where you can choose to embroider any flower of your choice.

- I use French knots instead of Colonial knots as it is easy to change the texture or thickness of the French knot by making one, two, three or even four wraps according to the size desired.

- Every flower and leaf differs from the rest. Not one rose will be exactly the same as the next. Very few of my students are really happy with each flower they make. Remember that once the entire picture is completed, you will not notice each separate flower or leaf in the design. Don't get caught hung up on one stitch – remember the bigger picture!

- Don't be concerned about what the back of your work looks like. There will be a lot of interlaced threads and ribbons after a while. No one will see the back of your work once it is framed! You will, however, have to be careful not to run a thread along any of the light-coloured areas without embroidery covering the front of the work. This will be noticeable once the work is framed.

- You should not 'jump' to another stitch if it is more than 2,5cm (1 inch) away. Rather end off and start again.

- Tidy up all the threads and ribbons along the outer edge of the design before framing.

- Thread or ribbon must pass through the fabric easily. If it does not, change to a larger needle.

- If you are using a ribbon or yarn that is too thick to pass through the fabric, couch or secure it onto your design with tiny stitches. Couching thicker

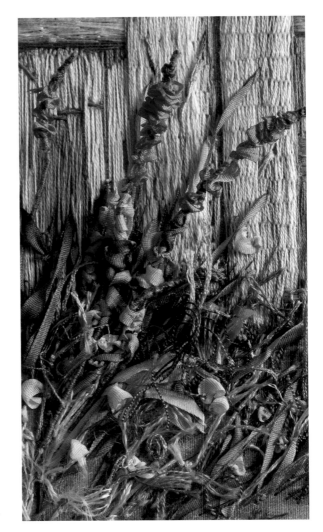

ribbons and yarns is also very effective. Couching is used for two reasons:

- Ribbon, yarn or wire is too thick to pass easily through the fabric without damaging it.

- In order to use less of the expensive ribbon or thread. One uses far less ribbon and thread if only couched on top of the design.

- Use the image in the book as a guide when choosing colour. Try to choose the same shade or even one or two shades lighter but feel free to change to whatever colours you prefer, for instance make lilac daisies instead of white ones.

- Remember that stitches in ribbon become larger and longer than you expect. When making the ribbon or chain stitches, for example, stay inside the painted section (1 mm inside the outer edge

is good). Once the stitch is formed, the ribbon spreads to become a larger stitch than generally expected.

- For rose leaves, rather make many small short stitches than a few long ones.
- Ensure that flower stems and long grasses and leaves grow from the ground, in other words the base of the design. Avoid the common mistake of making the stems too short, thereby letting flowers 'hang' in the air. Try to imagine that the stems (and long leaves or grasses) are growing out of the ground or pot as you stitch, without leaving a gap between the stem and flower. Add more stems weaving them underneath and over the existing stems for a more authentic look.
- For iris stems and long grasses, make stitches a few millimetres apart. Allow some of the printed background green to show through so that there is no large, uninterrupted, unwieldy mass of green which tends to spoil the balance of the design.
- Remember that some of the special effects require that you wait for glue, glitter and so on to dry before proceeding to the next step. High humidity levels can slow down the drying process. Leave yourself enough time for this process.

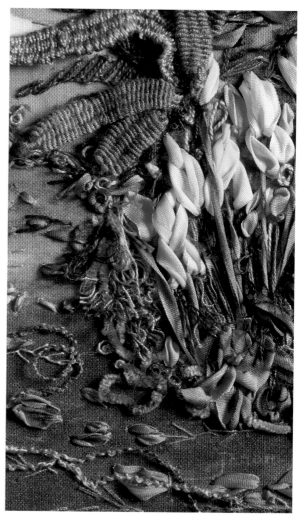

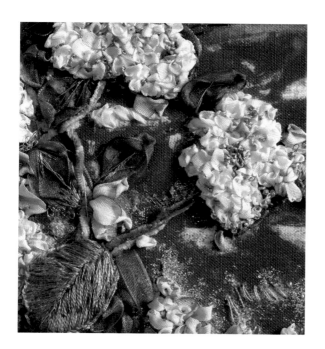

Suppliers

All designs and ribbons are readily available worldwide. For a list of your nearest supplier contact Di or Renn at The Red Shed, Lower Level, V&A Waterfront Shopping Centre, V&A Waterfront, Cape Town, South Africa

P O Box 461 Howard Place 7450, Cape Town, South Africa.

Tel +27 (0)21 671 4607/4 Fax +27 (0)21 671 4609

Mobile +27 (0)82 4584 700

pucketty@pixie.co.za

http://www.kalahari.net (click on crafts & hobbies, then on needlecraft)

Bottoms Up by Spencer Coleman

Courtesy of Felix Rosenstiel's Widow & Son Ltd., London

Embroidered by Di van Niekerk

Bottoms Up

Artist Spencer Coleman by courtesy of Felix Rosenstiel's Widow & Son Ltd., London
Embroidered by Di van Niekerk T/A Crafts Unlimited
The Red Shed, Ground Floor, V&A Waterfront Shopping Centre, Cape Town
Tel +27 (0)21 671 4607/4 Fax +27 (0)21 671 4609 pucketty@pixie.co.za

Copyright subsists in this work.

Size of completed image as shown approximately 41 x 28 cm

You will need

A good quality image on pure cotton fabric, 60 x 60 cm available from Di van Niekerk.

For the stump work, one extra image of children and dog on 45 x 45 cm fabric – enlarged by 5%. The figures need to be slightly larger as they tend to 'shrink' once embroidered.

Threads

Six-strand cotton		
Chameleon 6 Autumn Leaves	Chameleon 17 Clotted Cream	DMC Blanc (white)
Chameleon 42 Kalahari	Chameleon 72 Sea Shells	DMC 317 Medium Grey
Chameleon 49 Mahogany	Chameleon 66 Rustic Brick	DMC 318 Light Grey
Chameleon 7 Baked Earth	Chameleon 74 Silver Birch	DMC 413 Dark Grey
Chameleon 25 Desert Sands	Chameleon 30 Fern Green	NeedleArts 95 Dark Green
Chameleon 36 Golden Green	Chameleon 85 Sweet Melon	NeedleArts 157 Oyster
Chameleon 44 Lavender	Chameleon 83 Summer Sunset	

Pure silk		
Gumnut Aztecs Agate DK	Gumnut Aztecs Jade DK	Gumnut Aztecs Amethyst DK
Gumnut Aztecs Sapphire DK	Chameleon 37 Goldrush	Chameleon 23 Daffodil
Chameleon 62 Plumbago	Chameleon 77 Spilt Milk	Chameleon 54 Moss
Chameleon 33 Forest shade	Chameleon 19 Cobalt	

Like silk		
Chameleon 97 Green Olives	Chameleon 66 Rustic Brick	Chameleon 54 Moss
Chameleon 57 Olive Branch	Chameleon 9 Blue Bells	Chameleon 68 Scottish Heather
Chameleon 51 Marigold	Cameleon 37 Goldrush	

Perlé		
Chameleon 1 Amber	Chameleon 83 Summer Sunset	Chameleon 37 Gold Rush

Rayon	Bouclé – fine	French ribbon
NeedleArts 42 Lime	Threads for Africa Forest Green	Ribbon Connection G Moss

Rayon chain cord		
Threads for Africa Forest Green and Purple	Threads for Africa Metallic Green	Threads for Africa Light Olive

Metallic threads	
Kreinik 93 Lavender/Mauve	DMC White 5272 or Madeira 40 Colour 300 White

Ribbons

2 mm silk: Di van Niekerk's hand painted			
Di v N 26 Ivy	Di v N 33 Autumn	Di v N 35 Pine	Di v N 118 Kiwi
Di v N 22 Dark Olive	Di v N 100 Deep Shade	Di v N 83 Forest Green	

4 mm silk: Di van Niekerk's hand painted			
Di v N 118 Kiwi	Di v N 26 Ivy	Di v N 83 Forest Green	Di v N 49 Salsa Orange
Di v N 79 Pickle	Di v N 91 Flame	Di v N 14 Silver	Di v N 99 Old Gold
Di v N 104 Touch of grey	Di v N 113 Dark Plum	Di v N 60 Red	

Needles

Mixed pack crewel/embroidery size 5/10	Mixed pack chenille size 18/24	Large tapestry needle or cable needle for the looped stitches

Other

#24 white or green cake decorating wire	#26 white or green cake decorating wire	Ball of toy filling or shredded wadding for stuffing the shapes.
1 red or clear necklace bead for the ball	25 x 25 cm white cotton fabric for amber jersey, hat, and basket	Anti-fray agent
18 inch quilting hoop	14 inch quilting or embroidery hoop	8 inch embroidery hoop
Pins	60 x 60 cm polycotton or muslin to back the main design	Small embroidery scissors with sharp points
Sharp white or silver pencil crayon	Sharp HB or 2B pencil	

Stitches

Antwerp edging	Back stitch	Blanket/buttonhole stitch
Ceylon stitch	Chain stitch – continuous and detached	Cloud filling stitch
Couching	Crested chain stitch	Cross stitch
Detached buttonhole	Double blanket stitch	Feather stitch
Fly stitch	Knotted chain stitch	Four-legged knot stitch
French knots – normal and loose	Interlacing band stitch	Ladder stitch
Long and short stitch	Loop stitch	Net filling stitch
Overcast stitch	Pistil stitch	Raised stem stitch
Ribbon stitch	Rope stitch	Running stitch
Satin stitch – padded	Scroll stitch	Seeding stitch
Slip stitch	Split stitch	Stem stitch
Stem stitch – whipped	Stem stitch filling	Straight stitch – loose, twisted and folded
Turkey stitch/single knotted stitch	Wave stitch (looped shading stitch)	Woven filling stitch

Techniques

Padding a shape	Making a tassel (ponytail)	Covering a bead
3-D embroidery	How to make hair	New ideas for grass

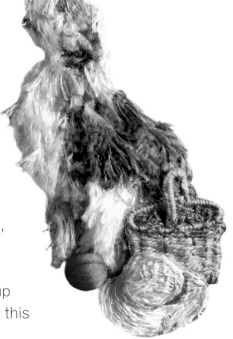

This enchanting painting is just made for stumpwork and it is fun to make too! It has lots of appealing elements that will certainly enthral many an onlooker.

I embroidered the children, dog, basket, and hats separately and then added them on top of and underneath the slats of the gate. This project is surprisingly easy to make. Although it takes time, not one of the stitches is difficult to do. You will learn how to add interesting texture with the green trees in the background. The grass and flowers in front of the gate look almost real and this project will teach you how to make detached, wired flowers, and wispy tufts of grass – a technique you are sure to use in future projects. I will teach you how to make appealing jerseys, long hair and short, and you will be able to brush up on long forgotten stitches to add the interesting features in this design. Enjoy!

ℐnstructions

The techniques used in this design are similar to 3-D decoupage where layers are added on top of each other to create an interesting three-dimensional texture in the design. You will be working with two layers at first: The main design is inserted in the large 18 inch hoop, with a backing fabric and the second slightly enlarged design is worked on smaller 14 inch hoop (no backing). The reason why the second design is enlarged by 5 per cent is that the shapes tend to shrink as you embroider them and they need to be slightly larger when attaching them to the main design. One child (or shape) is embroidered at a time. The embroidered shapes are then cut out and attached to the main design. Finally, separate shapes such as the hat, basket, and amber jersey are drawn and embroidered on a third layer of white fabric and attached on top to create a third dimension. Follow the step-by-step instructions and you will see just how easy it is!

ℭhe background trees

Stems, branches and leaves

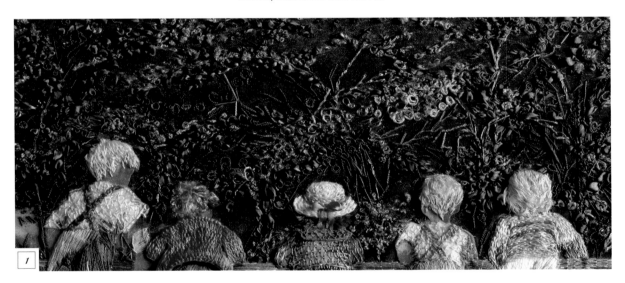

First form the **stems and branches** of the trees. Even if you are unable to see the branches in a design, it is always good to build a framework first, so that you can 'grow' the leaves from the branches in their natural state. Use variegated ribbons and threads in natural tones for a realistic finish. Using the photograph on the following page top left as a guide, draw the stems and branches on the main design in the 18 inch hoop. Use a silver or white pencil crayon for this

and refer to the main picture on page 22 for details.

Thread up with 2 strands of Chameleon Like Silk 57. Starting with the tree on the far right, lay the forest-green bouclé thread on top of the work, just above the top slat of the fence. Couch the bouclé in place with the Chameleon Like Silk 57 thread, following the drawing as guide when forming the various branches. It is not necessary to take the bouclé to the back of the work each time. Leave the bouclé on top of

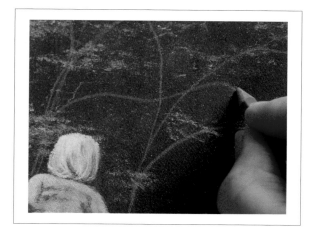

The **leaves** are formed with 2 mm and 4 mm silk ribbon with stitches in thread in between for an interesting texture. Use the following ribbons and threads and refer to the picture to match the colours:

2 mm silk ribbon: Di v N 26 for brown/olive leaves; 22 for medium bottle green leaves, 100 for purple green leaves, 83 for small bottle green leaves

4 mm silk ribbon: Di v N 118 for the light olive leaves, 83 for dark bottle green leaves, 113 for the dark grape coloured leaves, 26 for brown/olive leaves

Ribbon Connection French Ribbon G Moss

Chameleon Like Silk 97, 54, 57

Chameleon Stranded 30, 36

Threads for Africa Rayon Chain Light Olive, Metallic Green

Gumnut Aztecs Agate, Jade, Amethyst, Sapphire

Chameleon Pure Silk 33, 54

NeedleArts Stranded 95

the design, simply cut and start elsewhere again. The raw ends will be covered later with ribbon. But ensure that the raw end is attached to the fabric with the 2 strands of green thread.

Just to the left of the little girl with the hat, change to the rayon chain cord in forest green and purple and continue as above couching the thread in place. The dark tree trunks on the very left are embroidered in 1 strand of Gumnut Aztecs Jade and stem stitch, straight stitch, and fly stitch. Refer to picture 2.

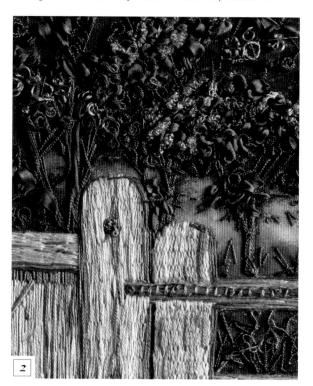

2

Start with the ribbon leaves to get a good idea of the texture required for the trees in this design. Then form the stitches with thread as shown picture 1 on the previous page. Use 4 mm silk ribbon for larger leaves and 2 mm ribbon for smaller leaves to ensure the correct dimensions in the design. Use the ribbons listed above and refer to the picture for the placement of the lighter and darker greens and the dark plum for the shadows. Refer to the main picture on page 22 constantly as you work.

Using silk ribbon, various stitches were used to form the leaves: loose and puffed ribbon stitch, loose straight stitch, loop stitch, detached chain. Select and blend the stitches as you like. Work from the branches outward for a natural texture.

Use threads as listed above and fill in some of the empty spaces between the ribbon leaves. Alternate the colours as shown in the main picture and use the following stitches: Turkey stitch or single strand knotted stitch; very loose French knots; fly stitch for the tiny branches; stem stitch and feather stitch for the thicker branches.

Using a size 18 chenille needle, work straight stitch in French ribbon to form the fluffy woolly leaves. If the stitch is too flat, lift it off the fabric with a blunt tapestry needle. Refer to picture 2.

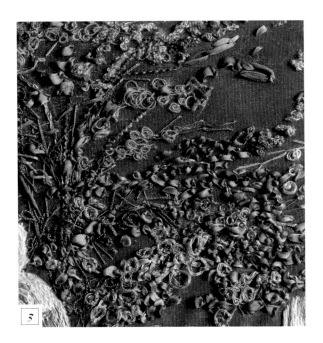

Leave some open space between the leaves. Study the picture on the left and note the shadows that are created when the spaces are left unfilled. Many embroiderers tend to fill in too much detail and end up with an unwieldy green mass that spoils the completed picture. To add interesting highlights use the metallic green rayon chain and French knots on the leaves above the little girl with the hat and on the far right. This adds 'sunlight' to the picture.

The grass behind the fence

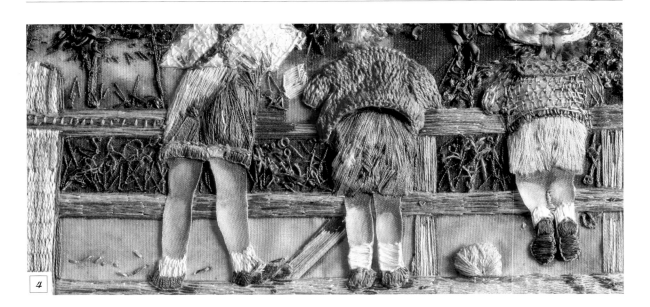

Work the grass at the base of the trees, behind the fence. Thread up with Di v N 2 mm Silk Ribbon 32 and use straight stitch, twisted straight stitch and folded straight stitch to form the thicker blades of grass. Twist the ribbon for some of the stitches to form thinner blades of grass. Change to the rayon chain cord and use straight stitch and fly stitch to form more blades of grass. Refer to the main picture – on the right of the little girl with the yellow jersey.

Use Chameleon Pure Silk 37 and Stranded 6 and work the golden coils of grass in loose french knots and single knotted stitch. Add long single knotted

stitches or Turkey stitch in between for more texture – refer to the main picture as a guide.

For the darker grass on the left use Gumnut Aztecs Jade and Chameleon Pure Silk 33.

For the grass beneath the boy on the far left use straight stitch and any of the lighter colours above.

Keep alternating the colours to imitate grass in its natural state, alternating between 1 and 2 strands for an interesting texture. Finally use 1 strand each of Chameleon Like Silk 66 and 68 to add a soft grey colour between the green leaves, using straight stitch and single knotted stitch. Refer to picture 4.

The fence

The fence, gate and gateposts

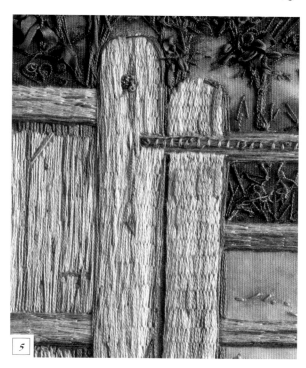

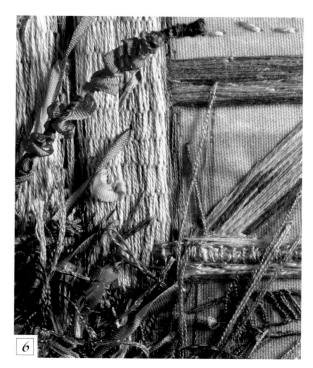

Refer to pictures 5 and 6. Fill in the fence (on the far left) and posts almost to the ground. Embroider over the painted flowers and grass to form a realistic picture. The flowers and grass are formed later on top of the embroidered fence. Thread up with 2 strands of Chameleon Stranded 66 and form the horizontal slats of the fence in raised stem stitch.

Fill in the fence. Work the dark lines that separate the logs with 2 strands of Chameleon Stranded 49. and split stitch. Then fill in the fence using 2 strands of Chameleon Stranded 66 and long and short stitch or stem stitch filling (row after row of closely packed

stem stitch). Use 2 strands of Chameleon Stranded 7 and form the dark brown shadows and cracks in the fence in straight stitch.

Hints

- Separate the 2 strands of thread first then put them together again before threading the needle. This allows for a smoother finish as the threads are not twisted.
- For a thicker texture use perlé no 8 thread in between the stranded. I used the Chameleon Perlé 83 on the gate post on the right.

THE GATE POSTS

Thread up with 2 strands of Chameleon Stranded 42 and work in raised stem stitch. Form the horizontal foundation stitches, then start the raised stem in the same thread. Change to Chameleon Stranded 74 to form the lighter stripes and then use Chameleon Stranded 85 so that an interesting change of colour fills the posts.

Hint on raised stem stitch

For an interesting variation, instead of inserting the needle under every foundation stitch, do so with every second stitch. Alternate every row. This prevents a definite pattern from forming and it is a faster way of completing the project.

Work the dark shadows in-between and on the right of the posts with 2 strands of Chameleon Stranded 49 and 7 in stem stitch and long straight stitches. Add straight stitches on top of the posts in the same dark brown threads to form the cracks, and French knots close together to form the round hole.
Repeat for the gate post on the right.

HINGES AND LATCH

Thread up with 1 strand of Chameleon Like Silk 66 and form the hinges on the left side of the gate in rows of stem stitch. Use the same thread and form short straight stitches on top of the stem for a raised effect. For the latch on the right, use 2 strands of Chameleon Like Silk 7 and straight stitch. Refer to pictures 7 and 8.

GATE

Refer to the main picture and picture 9. Only the top, second, fourth and bottom slats of the gate are embroidered – don't stitch the third slat until the little girl under the fence has been embroidered and attached (see page 39). The slat is embroidered afterwards so that her head fits under the gate. Use 2 strands of stranded thread to embroider the slats. Alternate between the following colours for an interesting

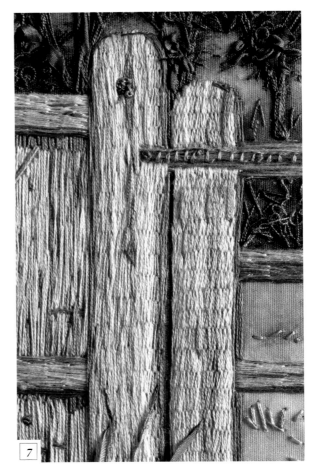

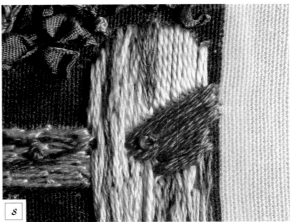

composition: *Chameleon 42, 49, 7, 25, 72, 66, 74, 85, 83*
NeedleArts 157

I used different stitches for an interesting texture on the gate. Choose from the following and alternate

stitches every now and then: raised stem stitch, stem stitch filling, long and short, long straight stitches and satin stitch.

Don't embroider over the hand of the boy on the far left, but **do** embroider over the children's legs and clothes, as each separate embroidered child is added on top of the gate at a later stage. Part of the gate shows through the children's legs and the gate looks more natural if embroidered before placing the shapes on top. The same applies for the fourth and bottom slats with the dog, grass and foliage. Embroider the slats as if there is nothing in front of them as the dog, grass and foliage are placed on top at a later stage.

To form the dark shadow at the bottom of each slat and on the right of the vertical slats use 2 strands of Chameleon 49 for some and 2 strands of 7 for others. Use stem stitch, split and/or straight stitch.

Refer to the picture below and form the dark shadows beneath the children's shoes, behind the dog's head, the basket and on the right of the children's bodies in the same thread and straight stitch.

The characters

Children and dog

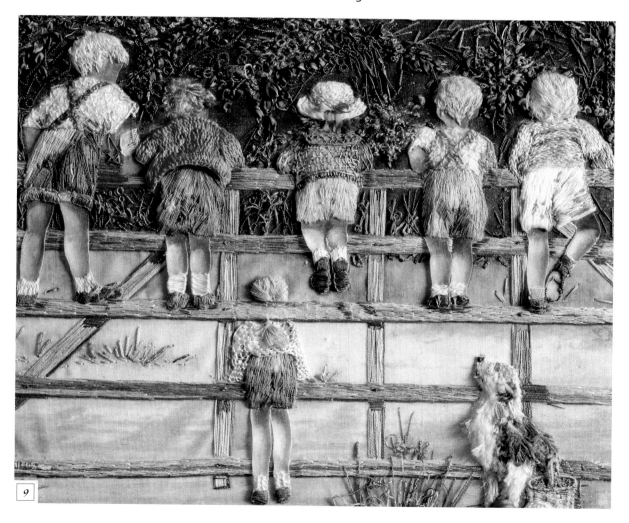

9

Embroider the children and the dog on the **extra, enlarged print**. The shapes are made separately then cut out and attached to the main design.

Hint

*For shapes that will be cut out, start with a knot in the thread but **don't** start anywhere near the edge of the shape. Bring the needle from the back of the work 5 mm away from the edge and make a few straight stitches to bring the needle to the edge. (These stitches are covered later, as you work.)This is important as you don't want a knot at the edge of the shape, that may be damaged when you cut out the shapes at a later stage.*

GIRL WITH PONYTAIL (CHILD 1)

Insert the **extra** design into the 14 inch hoop without backing cloth and stretch taut. Roll up 4 corners and pin or tack out of the way. Embroider the girl under the fence (Child 1) as follows:

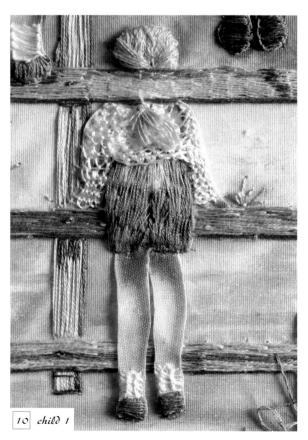

10 *child 1*

PANTS: Thread up with 1 strand DMC 317 and fill in the grey shadows in straight stitch. Change to 1 strand Chameleon Like Silk 9 and fill in the pants in straight stitch or long and short stitch working from the hem upwards. Use 1 strand of Madeira 40 Colour 300 and work the white highlights in the same stitch.

SOCKS: Use 1 strand of DMC Blanc and work Ceylon stitch to form knitted socks.

SHOES: Use 1 strand of Chameleon Stranded 25 and work the shoes in padded satin stitch.

JERSEY: Use 1 strand of Chameleon Pure Silk 77 and outline the edges of the sleeves and the back of the jersey (under her arms) in back stitch. Fill in with net filling stitch with a loose tension to form a soft, lacy jersey. The hem will curl up as the stitches are free from the fabric. For a pronounced curl embroider several more rows of loops.

HANDS AND LEGS: These are never embroidered to maintain the smooth flesh appearance.

HAIR: The ponytail is made like a tassel. Use a 2½ cm (1 inch) folded card or any thick paper and wind all 6 strands of the Chameleon stranded cotton no 42 or 85 around the card. See making a tassle in the stitch glossary.

Tie the threads with a few knots, one on top of the other, at the top edge of the card and cut open at the bottom to form a ponytail.

tassel so that the ponytail and the rest of the hair blend in well.

Hints

- *All the shapes are made on the extra enlarged cloth. Right-handed embroiderers should embroider the rest of the children from left to right so that none of the stitches are damaged. Start with child 6, 5, 4, 3, and then child 2. Left-handed embroiderers need to reverse the sequence and embroider from right to left: child 2, 3, 4, 5, and then child 6.*
- *Pull the fabric taut and tighten the hoop every now and then for a perfect finish.*

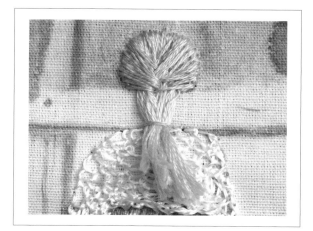

CHILD 6

Embroider the boy with the brown pants, still working on the additional enlarged design in the smaller hoop.

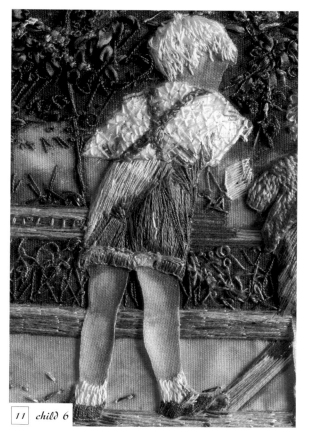

Attach the tied end of the ponytail with tiny stitches to lie just above the slat of the gate (the ponytail lies over the slat of the gate at this stage) Use 2 strands of the same thread and loose, padded satin stitch to complete the hair. Stitch over the tied edge of the

11 *child 6*

PANTS: Refer to picture 11. Use 1 strand of Gumnut Aztecs Jade and straight stitch to work the very dark grey lines on the creases of the pants. Change to Chameleon Like Silk 51 and work the golden yellow highlights on the pants in stem stitch or straight stitch. For dark brown shadows use 1 strand of Chameleon Stranded 49 and straight stitch or long and short. The turn-ups on the hem are embroidered in 1 strand of Chameleon Stranded 25 for the right leg and 66 for the left. Use double blanket stitch for a neat edge on both sides of the turn-up. Use stem stitch in Chameleon Stranded 66 for a pronounced edge. Add the white highlights on the pants in straight stitch using 1 strand of Chameleon Pure Silk 77.

BRACES: Thread up with 2 strands of Chameleon Stranded 49 and work in crested chain stitch.

SOCKS: Use 1 strand of DMC Blanc and work vertical rows of chain stitch for a knitted effect.

SHOES: Use 1 strand Chameleon Like Silk no 66 and padded satin stitch to form the shoes.

SHIRT: Use 1 strand of Gumnut Aztecs Jade and fill in the dark lines on the shirt in straight stitch. Thread up with 1 or 2 strands of Chameleon Pure Silk 77 and make white cross stitches at random to form an interesting pattern on the shirt. The edge of the right sleeve is made with same thread and a whipped stem stitch. Highlight the mauve shadow under the right arm in straight stitch using 1 strand of Chameleon Like Silk 9.

HAIR: Thread up with 1 strand of Chameleon Stranded 72 and use very loose straight stitch **formed over a thicker needle** to lift the hair. Start at the nape of the neck and work towards the top of the head. Keep lifting the stitches off the fabric with the thicker needle. Change to Chameleon Pure Silk 23 and, in the same way, work straight stitches over and in between the previous stitches to add highlights.

On the main design in the large hoop, embroider the bandage on the right arm in rope stitch using 1 strand of DMC Blanc. Change to Chameleon Like Silk 68 and use straight stitch to fill in the grey shadows on the bandage.

CHILD 5

Embroider the boy with the amber jersey.

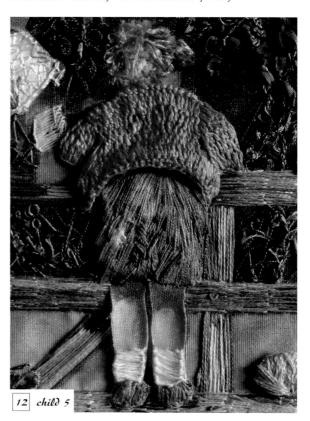

12 *child 5*

PANTS: Thread up with 1 strand of Chameleon Like Silk 68 and use long and short stitch to fill in the darker grey areas on the creases of the pants. Use 2 strands of DMC white metallic thread and add the white highlights in straight stitch. Change to 1 strand of Chameleon Like Silk 9 and fill in the remaining blue area in long and short stitch.

SOCKS: Use 2 strands of DMC Blanc and work the socks in interlacing band stitch.

SHOES: Thread up with 2 strands Chameleon Stranded 25 and use a padded satin stitch for the shoes.

JERSEY: This is on a third layer done at a later stage (see page 41).

HAIR: Work several layers to achieve a tousled look. Thread up with 1 strand of Chameleon Stranded 66 and use pistil stitch with a loose knot (don't tighten the knot around the needle as it is inserted to the back of the work). Work from the centre of the head

outwards to form the dark hair at the nape of the neck and ear. Thread up with 1 strand of Chameleon Stranded 72 and work another layer of pistil stitch over the first. Add loose straight stitches in between for highlights. Finally use 1 strand of Chameleon Stranded 25 and work a few single knotted stitches or Turkey stitch for the red highlights. Trim quite long and fluff.

CHILD 4

Embroider the girl with the hat.

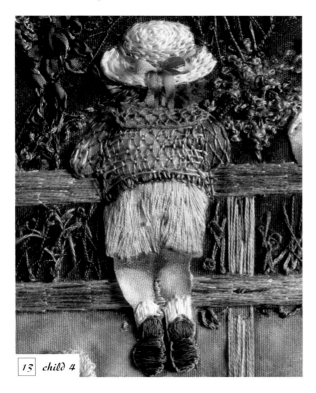

13 | child 4

PANTS: Embroider the darker lines on the crease of the pants in 1 strand of Chameleon Like Silk 66 and straight stitch. Use the same thread and horizontal lines of back stitch along the hem of the pants. Thread up with Chameleon Like Silk 51 and use long and short stitch to fill in the yellow parts, stitching over the back stitch along the hem for a padded effect.

SOCKS: Use 1 strand of Chameleon Pure Silk 77 and work interlacing band stitch for the socks.

SHOES: Use 1 strand of Chameleon Like Silk 66 and padded satin stitch to form the shoes.

JERSEY: Thread up with 1 strand of Chameleon Pure Silk 19 and stitch along the square edge of the collar in back stitch – be sure to make square corners. Use the same thread and fill in the dark shadows under the collar in tiny, short, straight stitches. Outline the jersey edge under the arms at the elbows in back stitch. The hem of the jersey is stitched in the same thread. Use a blanket stitch to form a ribbed edge.

Thread up with 1 strand of Chameleon Like Silk 9 and use open buttonhole stitch to fill in the collar. Change to 1 strand of Chameleon Pure Silk 62 and use cloud filling stitch to fill in the jersey. Then use 1 strand of Pure Silk 77 and thread or weave underneath the cloud filling stitch to make long straight stitches for an interesting effect. Work a few white straight stitches at the left elbow in same white thread for highlights.

HAIR: Cut a piece of card 1,2cm wide. Wind 2 strands of Chameleon Stranded no 49 around the card to cover an area wide enough for the girl's hair. Thread 2 strands of the same thread through the top edge and tie loosely so that the hair is wide and flat. Cut the strands at the bottom edge and fluff slightly. Keep hair aside to attach to the main design later (see page 40).

HAT: Embroider the rounded top, flat part of the hat first in 2 strands of Chameleon Stranded 17. Use a continuous chain starting at the centre and working round and round until the flat part is filled. Work the side of the hat in rows of chain stitch using 2 strands of Chameleon Stranded 42. Fill the brim using 2 strands of 17 and curved rows of chain stitch. The ribbon bow is added at a later stage (see page 40).

CHILD 3

Embroider the boy with the white shirt and blue pants.

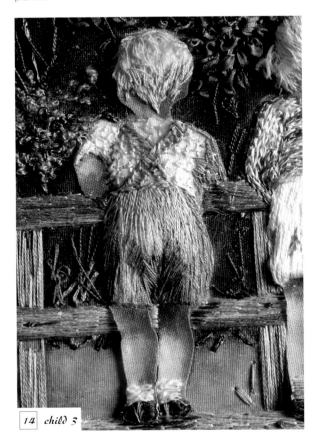

child 3

BRACES: Use 2 strands of Chameleon Stranded 44 and ladder stitch to form the braces.

PANTS: Use the same thread and form an interesting waist band of the pants in scroll stitch. Fill in the lighter pink/blue of the pants in 1 strand of the same lavender thread and long and short stitch. Change to 1 strand of white metallic thread and use straight stitch to highlight the white bits. Add the darker shadows in straight stitch or long and short stitch using 1 strand of Chameleon Like Silk 68 for the grey lines and Chameleon Like Silk 9 for the blue mauve shadows.

SHIRT: Use the same thread and straight stitch to form the dark shadows on the right arm and back. Do the same for the shadows at the left arm. Thread up with 1 strand of Chameleon Pure Silk 77 and use four-legged knot stitch for an interesting texture on the shirt.

SOCKS: Use 2 strands of DMC Blanc and work horizontal chain stitch to fill the socks

SHOES: Use DMC Stranded 413 and padded satin stitch adding Gumnut Aztecs Agate in between for a richer leather. Use 1 strand of white metallic thread and straight stitch for the highlights.

HAIR: Start at the nape. Using 1 strand of Chameleon Stranded 42, work loose straight stitches overlapping each other. Change to Chameleon Like Silk 51, work Turkey stitch or single knotted stitch over the first layer on the top of the head and in the centre. Add highlights above the ears using the same stitch and 1 strand of Chameleon Pure Silk 23.

CHILD 2

Embroider the girl with the yellow jersey.

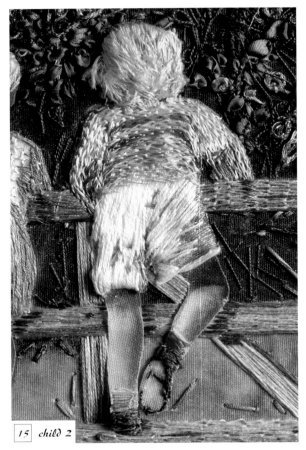

child 2

PANTS: Refer to picture 15. Thread up with 1 strand Chameleon Like Silk 9 and form the blue shadows on the pants in straight stitch. Change to Kreinik 93 metallic thread and continue filling in the mauve shadows on the pants in the same stitch. Change to 1 strand of DMC Stranded Blanc and fill in the remaining area with long and short or straight stitch.

SOCKS: Thread up with 1 strand of Chameleon Pure Silk 37 and work the socks in padded satin stitch.

SHOES: Work the shoes in the same way using 1 strand of DMC 413. Use 1 strand Gumnut Aztecs Agate in between the grey for a richer effect.

JERSEY: The jersey is worked in row upon row of chain stitch. Use 1 strand of Chameleon Pure Silk 37 for the darker rows and 23 for the lighter ones. Add a row of chain stitch in the darker thread along the edge of the left arm to create a shadow. Use open buttonhole loops or net filling stitch as for Child 1 along the edge of the last row of chain for a looser hem. Use 1 strand of Chameleon Like Silk 51 and work 5 or 6 rows.

HANDS AND LEGS: The right hand is not embroidered and remains in the shadows on the main design. The legs are not embroidered to retain a smooth flesh look.

HAIR: Thread up with 1 strand of Chameleon Like Silk 51 and work the hair in loose stem stitch and straight stitch. Start at the top of the head and work down. Change to 1 strand Chameleon Pure Silk 23 and make a few long Turkey or single knotted stitches to form the fluffy part of the hair. Work from the outer edge toward the nape of the neck. Change to 1 strand of Chameleon Stranded 42 and use a few straight stitches to add the darker shadows at the nape of her neck.

Hint

To achieve a perfect hem on the pants, first outline with stem or back stitch and cover (stitch over) these stitches as you embroider the rest of pants.

Dog

Here Turkey stitch is used extensively. Once the stitches are cut and fluffed out the area becomes very full; therefore it is better not to make too many stitches, too close together. Stay 1 or 2 mm inside the edge of the shape. Cut and fluff the stitches every now and then to gauge how many stitches are still needed. It is better to go back and fill in than to have too heavy a texture. Work from the bottom upwards so that the stitches overlap, and use the needle holding the loop to pull the stitch downwards. Allow the loops to lie flat against the fabric before cutting and fluffing.

Start with the grey shadows on the legs. Use 2 strands of DMC 318 and work Turkey stitch on the grey areas of the legs, from the paws upwards. Remember to work 1 mm inside the edge. Change to 1 strand of Chameleon Pure Silk 77 and do the same for the white part of the legs and chest.

Thread up with 2 strands of DMC 413 and work Turkey stitch to fill in the dark grey patches on the dog's

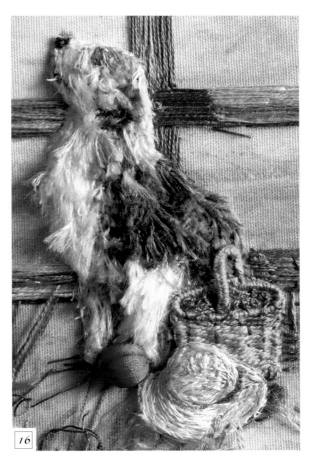

16

back. Do the same for the dark grey shadows behind the ear. Change to 2 strands of DMC 317 for the lighter grey patches on the back. Thread a needle with 1 strand of DMC 318 and 1 strand of 317 and fill in the remaining grey areas on the back. Do the same for the light grey on the ears and at the eye.

Use 1 strand of DMC 413 and work padded satin stitch for the nose. Form the triangle of the eye and

mouth with the same dark thread in straight and stem stitch.

Change to 1 strand of Chameleon Pure Silk 77 again and outline the white part of the mouth, nose, and back of head in stem stitch. Use same thread and Turkey stitch to fill in white patches on the head, back of the neck and back leg. Add white streaks on the back. Brush gently with the sharp point of the scissors.

Cut out the shapes

There are now 7 embroidered shapes to cut out and attach to the main design. Apply an anti-fray agent along the edges of the entire shape (including the threads) before you cut.

The agent dries clear and prevents the fabric from fraying. It also stiffens the shapes slightly which helps shape them in the next step. This is the fun part!

Use small embroidery scissors with fine, sharp points. Ordinary embroidery scissors with thicker points will make fine cutting very difficult.

First cut out **Child 1** as she needs to be placed under the fence. Insert the scissors in the fabric a short distance away from the edge and cut out a rough shape that is neatened in the next step.

As neatly as possible, cut along the edge of the sleeves (the hands will show on the main design). Cut along the pants, legs, jersey and hair. Go back and neaten if necessary.

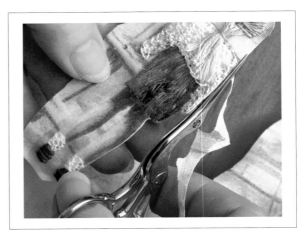

Place girl on main design aligning her shoes and head with that on the main design. Attach in place with 1 strand of any matching thread. Use a slip-

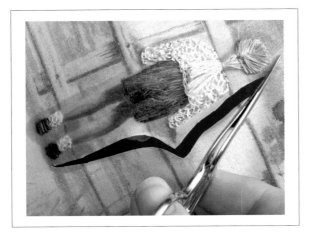

stitch here and there, aligning the slat of the gate first, and then the shoes. Note that it is not necessary to stitch along the edge of the legs and sock; leave these free – they won't fray as you have used an anti fray agent. Leave a small gap along one edge of the pants to insert a piece fiiling to pad the shape afterwards. Use quite loose stitches at the top of the head for a more natural look.

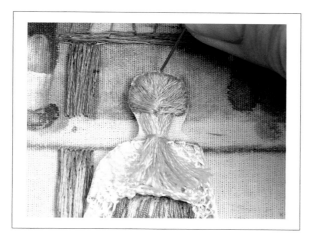

photograph of the completed design (see page 22) and note that the filling was placed at her waist and pants so that she appears to be bending under the fence. Use a matching thread and close the gap with slip stitch.

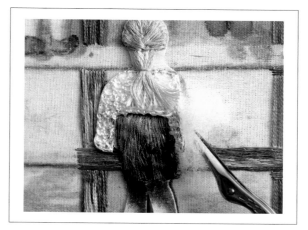

Thread up with 2 strands of matching thread for the third slat of the gate (see page 30) and embroider the slat over the girl's hair.

Use scissors to insert tiny bits of toy filling through the gap left at the edge of her pants. Refer to the

Cut out child 6 and repeat the process (refer to picture 11). Be careful not to damage the adjoining child. Cut along the right sleeve of child 6 as the arm will show on the main design. Refer to the main picture (see page 22) and note how the boy was placed on the gate. There are no anchoring stitches along the legs and face. Leave a small gap at the edge of the pants, fill, and close as before.

Child 5 does not yet have his jersey on. Once you have placed him, fluff out his hair a bit more to give him more character. Fill the shape as you did for the other children.

Child 4 is cut out to form 2 shapes. The hat is cut out as a separate shape and the body is cut along the same edges as the others but also along the neck of the jersey. Attach the girl's body (without the head) to the fence leaving a gap along the edge of the trousers, and fill. Then attach the hair you made earlier onto the main design and fluff out slightly. The hat is placed on top of the hair and attached at the top and sides. Leave the lower rim loose. Insert a length of Di v N 4 mm Silk Ribbon 49 in a chenille needle, and tie a knot at the long end. Bring the needle from the back of the work to the front at the side of the hat and leave a length on top of the hat. Repeat on the other side of the hat. Tie a bow with the 2 lengths and use a needle and matching thread to neaten and attach to the hat. Cut off the extra lengths of ribbon and use the matching thread to catch the ends onto the hair.

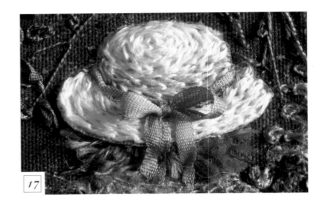

Cut out Children 3 and 2 and attach as before. Fluff out the boy's hair slightly and brush the girl's hair to lie towards the nape of the neck. Pad each child as before to achieve a pleasing shape.

Cut out the dog, and attach him to the main design, over the basket and ball – these will be added later. Tuck in the part under his chin – this adds more character. Leave the edge of his back free and pad his head and body with toy filling until he is nice and fat. Close the opening with slip stitch.

Adding the third layer

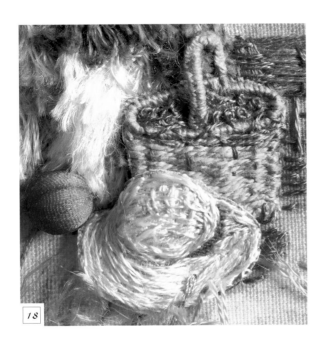

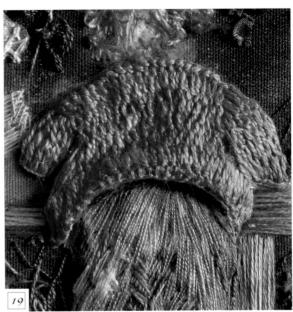

Use a very sharp HB or 2B pencil and carefully copy the outline and detail of the shapes below as neatly as possible onto the centre of the 25 x 25 cm white cotton fabric. Allow at least 1,2 cm (½ in) space between the shapes. Insert the fabric without backing in an 8 in hoop, pulling the fabric taut and tightening the screw. Roll up the four corners and pin or tack out of the way.

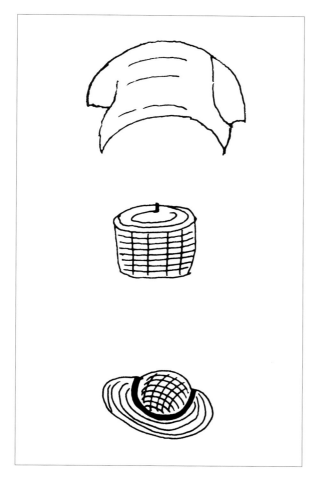

AMBER JERSEY

Embroider the amber jersey. Thread up with Chameleon Perlé 1 on a size 20 chenille needle. Use a wave stitch starting at the neck and working downwards. The sleeves are worked in the same way, starting at the top and working downwards.

BASKET

Work the basket. Use #24 wire and overcast stitch in one or two strands of Chameleon Like Silk 37 to anchor the wire along the oval rim of the basket. Start and end at the mark made on the rim – there is no need to take the wire to the back of the work, this will be covered by the handle. Thread up with Chameleon Perlé 37 and use a woven filling stitch to form the basket. To make the handle, refer to picture 18. Insert #24 wire to the back of the work and anchor with a few stitches on the back of the work. Bend the handle and insert the wire to the back of the work again. Use the same perlé thread and a detached buttonhole stitch to cover the wire of the handle. Fill the dark shadows inside the basket with tiny french knots using 2 strands of Chameleon Stranded 25. Use the same thread and a few straight stitches to form the darker brown lines on top of the basket.

HAT

Work the hat. Use 1 strand Chameleon Pure Silk 77 work a crisscross of straight stitch for the top of the hat and rows of stem stitch close together for the rim. Use 1 strand of Chameleon Stranded 85 and work the same stitches in between the others. Leave the dark band unstitched for an interesting effect.

ATTACHING THE SHAPES

Apply anti-fraying agent and cut out the shapes. Attach the amber jersey to child 5 as before. Bend the jersey into shape as you attach it and leave the hem free. Use the same amber perlé thread as before and work antwerp edging just along the hem of the jersey. Bring the needle up on the left side and stitch only along the freestanding edge of the jersey. Take the needle to the back on the right edge.

Attach the basket over the dog, leaving the handle free. There is no need to stitch along all the edges – only a few stitches are necessary. I did not pad the basket as the dog's body was fat enough. Place the hat over the basket. Insert filling under the rim for a nicely rounded hat.

MAKE THE BALL

Use Di v N 4 mm silk ribbon 60 and a size 22 chenille needle. See covering a bead in the stitch glossary.

Cover the bead as shown, starting and ending with a 5 cm (2 in) tail. Insert both tails into the needle and insert the needle from the front to the back of the work. Tie a tight knot with the tails at the back so the ball fits snugly onto the fabric. Cut away excess ribbon, taking care not to cut too close to the knot.

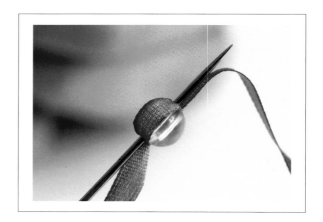

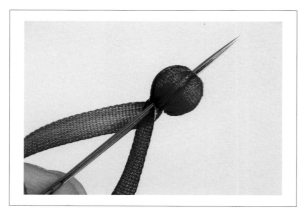

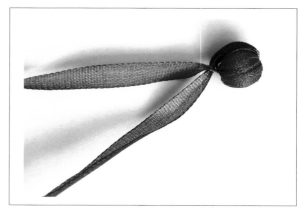

Grass and flowers

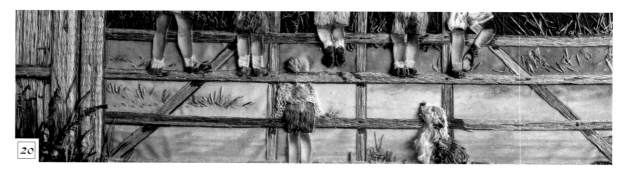

20

Refer to pictures 21 and 22. Start on the left and thread up with 1 strand of Gumnut Aztecs Agate and make long straight stitches and fly stitch to form the thin dark green grass at the back and over the fence. The small blades of grass in the ground on the right are made in the same thread and short single-knot-ted stitch. Change to the Gumnut Aztecs Amethyst and work the dark grey foliage in long Turkey stitch or single knotted stitch. It is not necessary to cut all the knotted stitches; leave some looped to form an interesting texture. Others can be cut to form loose grass. For bottle green leaves and the ferns use 2

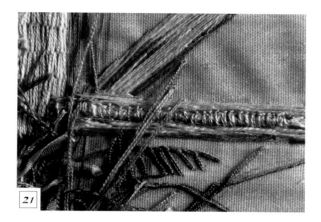

yellow detail in Threads for Africa Light Olive in the same stitch. Change to 1 strand of Chameleon Pure Silk 37 for more golden leaves. Use single knotted stitch and very loose french knots. Finally add darker green foliage in any of these stitches in Chameleon Like Silk and Pure Silk 54. Refer to picture 26.

Work the grass to the left of the little girl and the dog and on the far right using the same colours and stitches. Refer to pictures 23, 24 and 25.

strands of Chameleon Like Silk 97 and work straight stitch for the grass and blanket stitch for the ferns. Refer to picture 21.

Change to Di v N 2 mm Silk Ribbon to form the thicker blades of grass and the flower stems. Alternate between shades 33, 35, 118 and 22 and use straight stitch twisted and folded for an interesting texture. Refer to pictures 22 and 26.

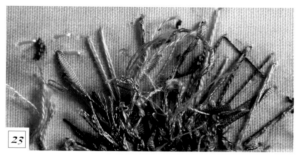

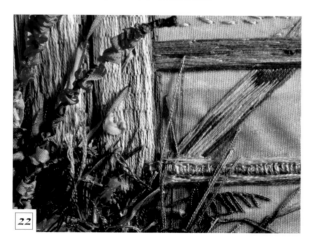

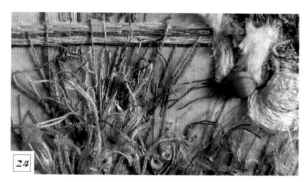

Add lemon and lime shades in between with Chameleon Stranded 36 and NeedleArts 42 using single knotted stitch and fly stitch or straight stitch as before, and autumn shades with Chameleon Stranded 6. Change to Di v N 4mm Silk Ribbon 79 and form the 2 large leaves in the picture. Use twisted straight stitch for the stems and detached chain with long anchoring stitches for the leaves. Fill up spaces between long leaves and stems with Chameleon Stranded 30 and shorter single knotted stitch. Work the golden

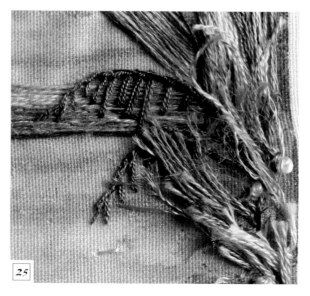

SMALL YELLOW AND WHITE FLOWERS

Work these with Di v N 4mm Silk Ribbon 99 and 105 in loop stitch and add a dark green french knot on top of some of the loops. Refer to picture 27.

TALL FLAME-FLOWERS ON THE LEFT

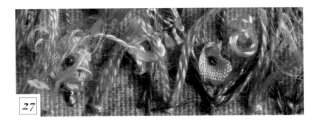

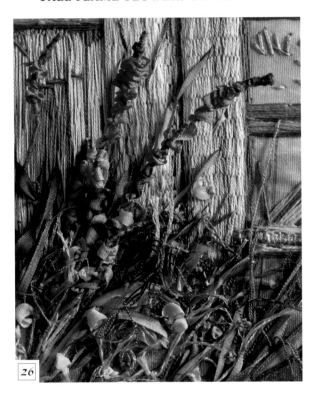

Cut 2 x10 cm (4in) lengths of #26 wire for the 2 longer stems and a 5 cm length for the shorter flower on the far left. Cut a 20 cm (8 in) length of Di v N 4 mm Silk Ribbon 91. Feed the entire length of ribbon onto

the wire to form a zig-zag concertina-like flower on the wire. Thread up with 2 x 80 cm (30 in) strands of NeedleArts Stranded 95.

Use an ear bud and run it over a glue stick Rub the glue along the tip to anchor the thread. Starting at

the top, wind the thread around the wire to form the green tip of the flower. Insert the needle into the edge of the ribbon before continuing to wrap the thread around the wire between flowers. Insert the needle through the ribbon for each section. As you proceed down the length of the wire, wrap the thread around

the raw end of the ribbon and continue until the end of the wire. Use the same thread to anchor the wire to the work after inserting it into the fabric. Move the foliage stitches out of the way and insert the stem as far down the design as possible – allow the stem to grow out of the ground instead of hanging in the air. Repeat for the other flowers. Refer to picture 26.

Thread up with Di v N 4 mm Silk Ribbon 14 and make loose loop and ribbon stitches at the base of each wire to form the silver leaves. For the leaves higher up on the stem, insert the needle into the thread wound around the stem. Continue making loop stitches into the previous ribbon loop. Work downwards again and end off at the base. Refer to picture 26.

Finishing off

To complete the picture, refer to the main picture on page 22. Add glitter on top of the sunny part on the trees, a little on the sun-dappled road and a few sprinkles on the dog. Glitter can also be added on the turn-ups of the pants of Child 6 and on the hair of Child 1. Refer to Floral Vista on page 105 on how to add glitter to your design.

Hydrangeas by Philip Wilson Steer Courtesy of Felix Rosenstiel's Widow & Son Ltd., London Embroidered by Di van Niekerk

Hydrangeas

Artist Philip Wilson Steer by courtesy of Felix Rosenstiel's Widow & Son Ltd., London
Embroidered by Di van Niekerk T/A Crafts Unlimited
The Red Shed, Ground Floor, V&A Waterfront Shopping Centre, Cape Town
Tel +27 (0)21 671 4607/4 Fax +27 (0)21 671 4609 pucketty@pixie.co.za

Size of completed image as shown approximately 40 x 30 cm

You will need

A clear image on pure cotton fabric, 60 x 60 cm square, available from Di van Niekerk.

Additional image printed on cloth of the hydrangeas that are made separately (only print the left quarter corner of the image, slightly enlarged – 5 or 10 per cent), available from Di van Niekerk.

Threads

Six-strand cotton		
Chameleon 33 Forest Shade	Chameleon 62 Plumbago	Chameleon 96 Purple Lady
Chameleon 11 Baobab	Chameleon 25 Desert Sands	Chameleon 1 Amber
Chameleon 15 Charcoal	Chameleon 66 Rustic Brick	DMC Stranded Blanc
DMC Stranded 934 Very Dark Green		

Pure silk		
Chameleon 49 Mahogany	Chameleon 15 Charcoal	Chameleon 37 Goldrush
Chameleon 77 Spilt Milk	Chameleon 98 Midnight Blue	Chameleon 95 Wisteria
Chameleon 8 Black Berry	Chameleon 85 Sweet Melon	Chameleon 23 Daffodil
Eterna 910 Copper	Eterna 940 Dark Copper	Eterna 1110 Dark Brown
Gumnut Aztecs Agate MD	Gumnut Aztecs Garnet DK	Gumnut Aztecs Ruby DK
Gumnut Aztecs Amethyst DK		

Metallic threads		
Madeira 40 Gold 3	Madeira 40 Black 70	Madeira 40 White 300
Madeira 40 Gold 8	Madeira 40 Peacock 270	Madeira 40 Black/Silver 460
Madeira 40 Copper	Madeira 40 Gold 4	DMC 5283 Silver
DMC 5272 White	DMC 5282 Gold	Kreinik 4 Braid Copper 021
Kreinik 4 Braid Orange 027	Kreinik 4 Braid Curry 2122	Kreinik Blending Filament Pearl 032
Kreinik Blending Filament Mauve 093		

Rayon
DMC 35200 White

Velvet cord
Threads for Africa 5 Moss

Ribbons: Di van Niekerk's hand painted

4 mm silk	
Di v N 109 Marigold	Di v N 77 Antique Cream
Di v N 104 Touch of Grey	Di v N 105 Touch of Green

7 mm silk	15 mm organza	6 mm organza
Di v N 67 Blue/Green	Di v N 23 Moss	Di v N 100 Deep Shade

Needles

Mixed pack crewel/embroidery size 5/10	Mixed pack chenille size 18/24
Mixed pack milliners/straw size 3/9	One large tapestry no 13 or doll's needle

Other

Old necklace with cream beads – not too large	Glitter	Glue stick (like the ones used at school)
Toy filling	60 x 60 cm white, light-weight fabric such as muslin, lawn, or polysilk	18 inch quilting hoop
10 inch embroidery or quilting hoop for the hydrangeas	60 x 60 cm cotton fabric for trapunto	Gold and bronze glitter for nails, body and decorative art

Stitches

Buttonhole wheels/closed buttonhole	Buttonhole/Blanket stitch	Couching	Fly stitch
French knot	Grab stitch	Lazy Daisy stitch/Detached chain stitch	Long and short buttonhole stitch
Long and short stitch	Open buttonhole stitch	Pistil stitch	Ribbon stitch
Slip stitch	Stem stitch and stem stitch filling	Straight stitch	Turkey stitch/Single knotted stitch

Techniques

Trapunto	Needlelace	Stumpwork

I simply could not resist this painting as it is just so ideal for creative embroidery. The lady's blouse lends itself to exotic golds and bronzes and beautiful lace and fluffy textures. The skirt was quite a challenge and I tried to create movement in the section almost sliding off the sofa by using rounded stitches. The white highlights were embroidered with a crisscross of metallic threads to simulate a very rich silk fabric. I hunted in antique shops for something to use for the pearls and bracelet and eventually I found some old costume jewellery in Kalk Bay.

The hydrangeas (see page 46) are embroidered separately and attached to the design to create a high relief. The embroidered cat and the left sleeve are filled with toy filling afterwards to raise the shapes – a method called Trapunto. Finally, to enrich the design, I added touches of gold glitter with stunning results. Enjoy bringing your design to life!

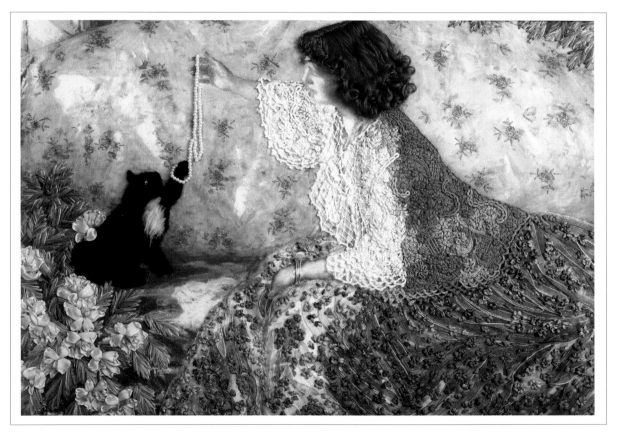

To show how each embroiderer interprets a design completely differently, I asked Elba Kruger to embroider the same design, and this is the beautiful result. Note how she skillfully used variations of buttonhole stitch on the blouse, and how she used my 6 mm organza ribbons for the foundation of the skirt. She then added little flowers on top in 2 mm silk ribbon.

The lady's hair is dolls hair couched in shape. The cream flowers on the left were made in ribbon stitch and 7 mm silk ribbon and the darker pink centres in 4 mm silk ribbon. The green leaves are straight stitch in 2 mm silk ribbon and 3 mm organza ribbon. Feel free to use your own artistic licence!

Instructions

Start with the lacy blouse as it will give you a good feel about the texture you need to use in the rest of the design. The shadow along the edge of the left sleeve is an integral part of the picture and separates the sleeve from the back of the blouse, clearly shown in picture 6.

Lacy blouse

Sleeves, scallops, shoulder, lacy front

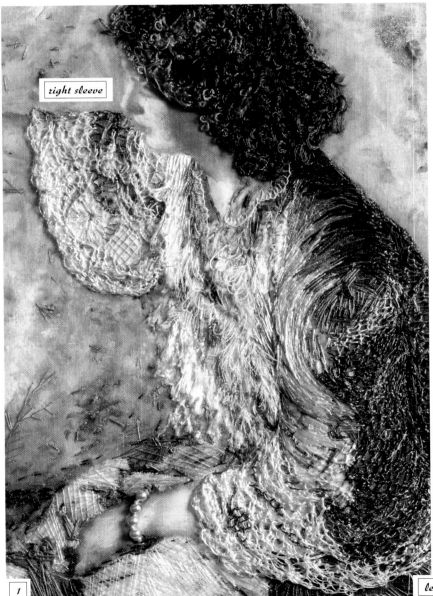

The left sleeve

Start with the white part of the left sleeve; refer to picture 1. Thread up with 1 strand of DMC Rayon 35200 and use stem stitch to form the white curved lines on the shoulder and arm. Leave space between the curved rows.

Change to 1 strand of Chameleon Pure Silk 77 and fill in the spaces between the curved rows with rows of stem stitch filling.

Change to 1 strand of Kreinik Blending Filament 032 and use stem or straight stitch to add white highlights between the rows of stem stitch. Use straight stitch for the white sections higher up on the left shoulder too, then change to 2 strands of Kreinik Blending Filament 093 and work the mauve sections on the same part of the sleeve in stem stitch.

The right sleeve and collar

Moving to the right sleeve (picture 2), form the crisscross lines with straight stitch and 1 strand of Chameleon Pure Silk 77. Make another layer of straight stitches on top of the first layer in the opposite direction. Use the same thread to work the daisy on the right sleeve in lazy daisy stitch then fill in the blouse under her chin in straight stitch. Change to 1 strand of Madeira 40 Gold 3 and work the centre of the daisy in tiny straight stitches.

Thread up with 1 strand of DMC Metallic 5272 and work the lacy collar in blanket stitch. Add a few straight stitches here and there in Madeira 40 Copper. See pictures 1 and 8.

Make the scallops on the left sleeve

Refer to pictures 1 and 3. Thread up with 1 strand of DMC Rayon 35200 white and work the first few rows of white scallops in open buttonhole stitch. Start just beneath the section you have embroidered and work from left to right. Pick up small pieces of fabric for the first line of stitches. Work in rows, and with each new row insert the needle into the loops you have formed working the previous row. Keep a loose tension so that the loops are nice and rounded. It is only necessary to take the needle to the back of the work

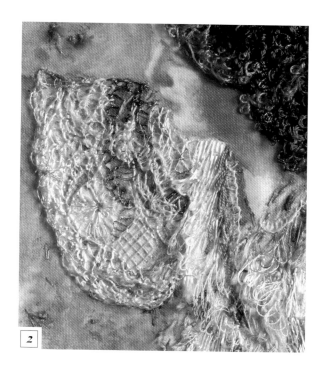

when you find the stitches curling up too much. I find it easier to anchor some of the loops to the background every now and then so that the stitches are flat and rounded. Then proceed as before inserting the needle only into the loops again.

After a few rows change to 2 strands of DMC Stranded Blanc and make a few more rows of open buttonhole. Change to 1 strand of Chameleon Pure Silk 77 and form another few rows. Along the edge of the sleeve, change back to DMC Metallic 5272 and complete with DMC Metallic 5283.

Adding colour

Thread up with Chameleon Pure Silk 23 and work a few more rows of open buttonhole stitch on top of the white ones, using picture 3 as a reference. Note the pale yellow near the edge of the sleeve – refer to pictures 3 and 5. Thread up with 1 strand of Kreinik 4 Braid 2122 and make the bronze patches on the sleeve in the same stitch. Work on top of the white layer as before.

Thread up with 1 or 2 strands of Madeira 40 Gold 8 and fill in the gold patches on the white sleeve in straight stitch. Add the dark blue patches in 1 strand of Chameleon Pure Silk 98. For the old gold stripes use 1 strand of Chameleon Pure Silk 37.

Use the same group of threads and stitches as outlined for the left sleeve and complete the right sleeve by referring to picture 2.

Shoulder

Refer to picture 4. The dark grey patches above the shoulder are filled in with straight stitch. Use stem stitch for the curved lines. Use 1 strand of Madeira 40 Black/Silver 460 for the black patches, alternating with 1 strand of Gumnut Aztecs Agate (MD) and 1 strand of DMC Stranded 934 (very dark green) for the dark green/brown sections. The lighter brown is worked in 1 strand of Chameleon Stranded 66. Highlight the bronze and gold sections using 1 strand of Kreinik Braid 027 and 1 strand of Madeira 40 Gold 8. Fill in the blue with Chameleon Pure Silk 98.

The dark part of the left sleeve

Refer to picture 5 and use the same open buttonhole stitch as before. Start at the top of the shoulder just below the light brown straight stitch. Working this section, start and stop at the *edge of the sleeve* so

4

5

6

that a definite folded shadow will appear on the completed jersey between the sleeve and the back of the blouse. Refer to picture 6 for the darker fold.

Thread up with 1 strand Chameleon Pure Silk 23 and work the pale yellow section first. Change to 1 strand of Madeira 40 Peacock 270 and work the darker blue/black section, then form the dark bronze patches using Kreinik 4 Braid 2122. Towards the bottom of the sleeve, change to 2 strands of Madeira 40 Gold 4 and end with 1 strand of Madeira 40 Peacock 270.

Thread up with 1 strand of Chameleon Pure Silk 77 and work open buttonhole over the darker stitches at the bottom edge of the sleeve, making a white edge with the dark colour showing through for an interesting effect. Add the light copper stripes working stem stitch on top in 2 strands of Madeira 40 Copper.

Finally work any remaining blue bits in straight stitch with 1 strand of Chameleon Pure Silk 98.

Back of the blouse

Refer to pictures 4, 6 and 7. Thread up with 1 strand of Kreinik Braid 027 and start at the top behind the shoulder, working 1 row of open buttonhole as be-fore. Change to 1 strand of Kreinik 4 Braid 021 and continue with the same stitch for 3 or 4 more rows, inserting the needle into the loops you have formed in the previous row. Keep your tension very loose and anchor some of the loops to the background now and then. Start another row of open buttonhole further down on the blouse. Leave the open space above this line to be filled later.

Thread up with 1 strand of DMC Metallic 5282 and make 2 or 3 rows of open buttonhole as before. Change to Kreinik Braid 2122 and continue for another few rows. Thread up with 1 strand of DMC Metallic 5282 again and make another few rows. Now work another row, refer to picture 6 as a guide, noting that it is worked in a different direction.

Thread up with Chameleon Pure Silk 23 and start another row of pale yellow open buttonhole. Change to Madeira 40 Peacock 270 and work a few dark rows, anchoring the loops if they curl up too much. Work 2 more rows in Kreinik Braid 2122 then change to DMC Metallic 5282, and alternate with any of the other gold threads for the remaining few rows. Finally, thread up with 2 strands of Madeira 40 Peacock 270 for the dark curved corner at the sleeve.

The hem of the blouse

The hem of the blouse on the far right is not attached to the fabric. For this effect, thread up with 2 strands of DMC Metallic 5282 and work open buttonhole on top of the previous stitches, starting 1 to 2 cm higher up on the hem. Start on the right, working into the previous layer of stitches. Change the direction to curve up towards the elbow. Start at the right again and this time work into the previous top (new) row of stitches. Repeat the rows, keeping a loose tension. Don't anchor the stitches as they curl up – the loose hem is an interesting feature.

Go back to the empty spaces and using the photograph as a guide, fill in with the same open buttonhole stitch. Make layers on top of layers in the different threads as you did with the sleeve to add more texture. At the top of the blouse use Kreinik 4 Braid 2122 and open buttonhole stitch running vertically as shown in picture 4.

Alternate 1 strand of DMC Stranded 934 and 1 strand of Gumnut Aztecs Agate to blend the dark colours at the shoulder using straight stitch and stem stitch. To work the shinier dark patches just underneath the hair, use the same stitches and 1 strand of Madeira 40 Black/silver 460. Refer to picture 4.

7

The folded shadow along the edge of the sleeve

Start at the top of the sleeve using 2 strands of DMC Stranded 934 and work short straight stitches at short intervals at right angles to the fold to form the shadow (see picture 7). Embroider the darkest shadows along the curve at the edge of the blouse in 1 strand of Chameleon Pure Silk 15 using stem stitch.

The sleeve is padded (a technique called Trapunto) at a later stage to bring the left arm out in high relief (see page 63).

Hint

Go back to the blouse and sleeve and add more layers on top of the previous ones to add more texture. Keep a loose tension!

8

The fluffy front panel

Refer to picture 8. This section is worked predominantly in Turkey stitch or single knotted stitch or loops. Note the golden patches. Thread up with 1 strand of Chameleon Pure Silk 37 and form the stripes from bottom to top. Don't make the stitches too close together to keep the texture soft and feminine. The loops are deliberately scruffy rather than than neat for a fluffy texture. Don't cut all of the loops – leave some stitches looped for an interesting finish.

Use 1 strand of any of the gold metallic threads and work a few shiny gold loops between the silk ones. Thread up with Madeira 40 White 300 and form the white loops closest to the left sleeve. Work loops beneath the collar in 1 strand of Chameleon Pure Silk

77. Work the white stripe between the two gold ones with Madeira 40 White 300. All these loops are cut. The darker grey/green loops beneath the right collar are worked in 1 strand of Gumnut Aztecs Agate.

Fill in empty spaces alternating 1 strand DMC Rayon 35200 and DMC Metallic 5272 and Turkey stitch. Add the dark purple/blue shadows along the left sleeve working straight stitch in 1 strand Chameleon Pure Silk 98. Use Kreinik Blending Filament 093 to add the mauve/lavender highlights between the blue. Work short black stitches between the loops below the collar using 1 strand Chameleon Pure Silk 15 and work the grey/green shadows at the elbow in Gumnut Aztecs Agate. Make a few straight stitches and loops in Madeira 40 Copper to add the final touch.

Skirt

Dark back section, fold and light front section

Use a single strand to work the skirt:
Kreinik Blending Filament 032
Madeira 40 White 300, Gold 8
Chameleon Stranded 11, 33, 62, 96

Chameleon Pure Silk 8, 77, 85, 95, 98
DMC Stranded 934, Metallic 5272
Gumnut Aztecs Ruby DK, Amethyst DK, Agate MD, Garnet DK

The dark section of the skirt

Refer to pictures 9 and 10. Start at the top right and work along the edge of the blouse towards the left. Thread up with 1 strand of Chameleon Stranded 33 and work semi-circles with blanket stitch wheels. Bring the needle out on the outside of the circle and keep inserting it back into the centre as the blanket stitch semi-circles are formed.

Don't make the stitches too close together – the texture is loose and flowing. Some buttonhole semi-circles are made on top of or overlapping previous ones.

Proceed along the edge of the blouse, choosing from the threads listed on the previous page, and keep referring to the pictures as a guide to match up the colours. Don't be too worried about exact colour placement as all the colours and textures will even out in the end. The lines between the semi-circles are worked in straight stitch, sometimes close together, sometimes further apart. Work fly stitch at the fold of the blouse using a blue and violet-blue thread. Remember not to fill all the spaces – keep the texture light.

The light part of the skirt

Refer to picture 11. The light front section below and above the hand is embroidered in white metallic threads: alternate the metallic white threads listed on the previous page. Use mostly 1 strand, but change to 2 strands every now and then for an interesting texture. Change to brown threads for the darker shadows.

The stitches used are straight stitch overlapping the previous layer, straight stitch close together or further apart. Keep referring to picture 11 to guide you. The criss-cross lines are straight stitches worked like the criss-cross section on the right sleeve. Make a few French knots every now and then to add heavier texture. Finally add the black lines in straight stitch in Madeira 40 Black 70. The glitter is added later.

10

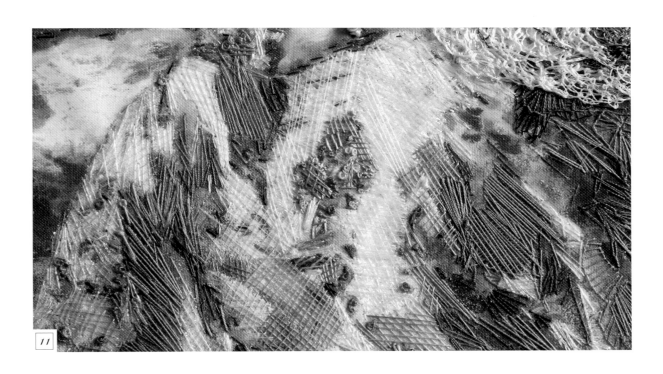

The sofa

Back of the sofa, sofa seat, wall and leaves

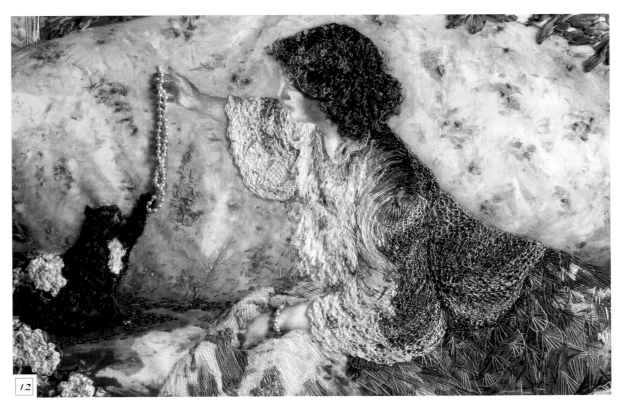

The back of the sofa

Work one or two single knotted stitches or Turkey stitch, close together and cut very short, alternating 2 strands of the following three colours: Chameleon Stranded 11, 25 and 1. Refer to pictures 12, 13 and 14 for placement.

Thread up with 1 strand of Madeira 40 Gold 4 and make a few more gold stitches. Work straight, feather and fly stitches in the same gold thread here and there for a richer finish. The gold glitter is added at a later stage.

Hint

Don't overfill the sofa detail; only embroider some of the amber flowers here and there to create distance in the picture.

Leaves and wall behind sofa

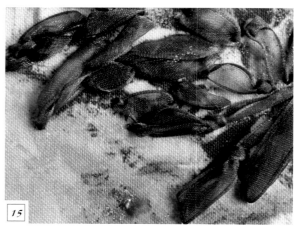

Refer to picture 15 and work the leaves behind the sofa (top right and top left) in Di v N 100 organza ribbon using ribbon stitch and detached chain. Use a grab stitch to anchor the chain stitches.

Sofa seat

Thread a medium straw needle with 1 strand of Chameleon Pure Silk 98 and work straight stitch to form the shadows under the cat on the sofa seat. Change to 1 strand of Gumnut Aztecs Agate and work the same stitch to add brown shadows along the fold of the seat towards the fluffy part of the blouse. See picture 12.

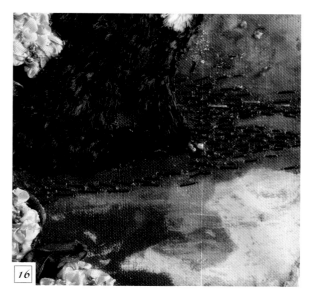

LADY'S HAIR

Embroider the hair, alternating the following 4 brown threads for life-like colour: Chameleon Pure Silk 49 and Eterna Silk 910, 940 and 1110. Make very loose French knots (don't tighten the thread around the needle) using only 1 strand at a time. Start at the parting and work down towards the nape of the neck. Change the shades every time you re-thread the needle. Work from the parting again towards her forehead to complete the picture. Use the lightest shade on the lightest part of her hair. The parting needs darker brown as does the nape of her neck. Finally add a bit of glitz in the same stitch with Kreinik 4 Braid 2122 at random intervals.

Cut some of the french knot loops if you like, to create an interesting texture.

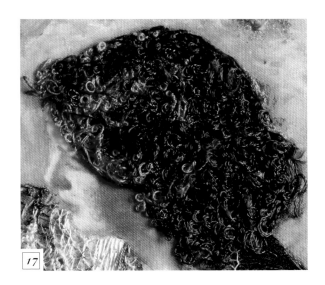

The cat

The cat is embroidered on the main design in back stitch, satin stitch and closely packed Turkey stitch. Use 1 strand of Chameleon Pure Silk 15 and start at the tip of the nose. Carefully outline the head in fine back stitch and then cover with satin stitch working from the tip of the nose outwards. Work the ear in the same way, from the head to the tip of the ear. At the ear, make a curved row of Turkey stitch. Refer to picture 18 to see where the fluffy hair starts. Leave a gap and start at the bottom, working upwards in rows or patches of Turkey stitch. Stop to cut the loops every now and then to get a good idea of the texture being formed. The paw and leg are made in the same way, but at the tip, add 1 or 2 stitches in the Chameleon Pure Silk 77 for the white spot. Proceed up the body to the head, cutting and fluffing the loops every now and then. Change to Chameleon Pure Silk 77 and work the white patch in the same way, then back to the charcoal to complete the cat, working towards the raised paw. Use Kreinik Blending Filament 032 and work single knotted stitches for the whiskers and between the stitches on the white patch for high-

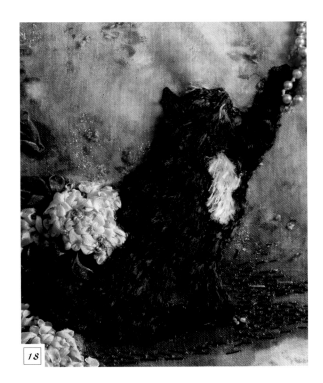

lights. The cat is padded later (a technique called Trapunto) to bring it out in high relief (see page 63).

LEAVES

Make the two stumpwork leaves: trace the two leaves below onto the pale sofa section of the **additional print** so that detail is clear. Use a sharp HB or 2B pencil and include the veins of the leaves.

Insert in a 10 inch hoop (no backing) pull the fabric taut and roll, pin or tack the corners out of the way. Embroider the leaves in long and short buttonhole stitch using 2 strands of Chameleon Stranded 33. Fill in the remaining space with long and short stitch. Add gold veins and shadows on the leaves with 1 strand of any of the finer gold threads using fly stitch and stem stitch. Set aside the embroidered leaves – don't cut them out yet.

MAKE THE SIX LARGE HYDRANGEAS

Still working on the **additional print**, embroider the six large hydrangeas as follows: thread a size 20 chenille needle with the Di v N 4 mm Silk Ribbon 109. Make loose puffed ribbon stitches to form the tan patches on the hydrangeas (refer to picture 19). Change to Di v N 77 for the lighter cream bits and Di v N 104 for the pale grey petals. Finally Di v N 105 for tinges of green. Work French knots (2 wraps) close together in 2 strands of Chameleon Stranded 33 to form the darker green patches. Set aside the embroidered hydrangeas – don't cut them out yet.

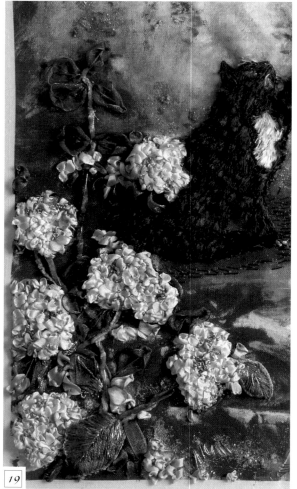

19

Make the Hydrangea stems

Refer to picture 19 and the main picture (page 46). Change back to the **main design** in the large hoop. Thread up with 2 strands of Chameleon Stranded 33 and couch the Threads for Africa Velvet Cord in place to form the hydrangea stems. Work over the hydrangea flowers and leaves on the design as these will be covered later. Whip the couched stem very loosely with 1 strand of Madeira 40 Gold 4 or 8 to add gold highlights.

Attach the shapes to the background

Cut out the embroidered hydrangeas leaving a 5 mm (¼ inch) seam allowance. Use 2 strands of brown cotton and attach the shape to the main design using slip stitch, fold the seam allowance under as you stitch. Leave a small gap open and insert a piece of filling under each flower before closing the gap. The large hydrangea on the right is attached on top of the cat. See picture 19.

Ribbon leaves and remaining hydrangeas

Use the largest chenille needle and thread up with Di v N 15 mm Organza Ribbon 23. Refer to pictures 19 and 20 and make the green leaves in ribbon stitch. Add gold highlights working straight stitch in 1 strand of Madeira 40 Gold 8 and Copper. Add a few scattered French knots on the flowers and background. Use 1 strand green thread and straight stitch to form the veins on the leaves at the very tip of the stem.

Embroider the remaining hydrangeas directly on the main design in the same ribbons and colours as those used for the large hydrangeas.

Refer to picture 19. Thread up with Di v N 7 mm Silk Ribbon 67 and fill in the blue-green leaves in ribbon stitch adding gold knots on top as before. Finally thread up with Di v N 6 mm Organza Ribbon 100 and work the dark purple leaves in the shadows between the leaves in ribbon stitch.

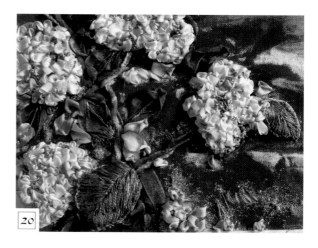

ATTACH THE STUMPWORK LEAVES

Cut out the two separately embroidered leaves. Use anti-fray agent along the edge before you cut. Refer to picture 19 to attach in place on the main design. Use two strands of any matching thread and slip stitch along the rounded edge. Allow the tips of the leaves to stand free for a raised effect.

Hint

The buttonhole stitch on the leaf allows for a neat edge that does not require a wired edge as one would normally do in a stumpwork design. The leaf is more natural this way.

Necklace and bracelet

Measure the necklace (add an extra bit so that the necklace can twist nicely) and cut off the required length. The 2 raw edges of the necklace are attached at the top of the hand using 1 strand of Chameleon Pure Silk 77 and an overcast stitch, allowing the folded section to lie on top of the cat's paw. Couch the necklace in place at random intervals allowing most of the necklace to hang free.

Repeat for the bracelet.

Hint

If you are unable to find an old necklace, make a necklace and bracelet from tiny cream beads and attach.

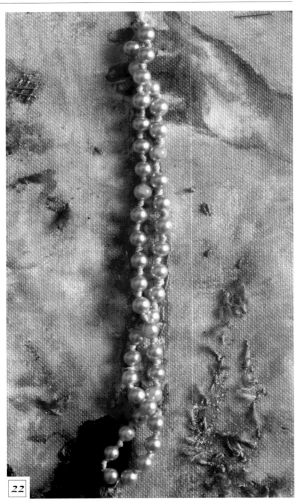

22

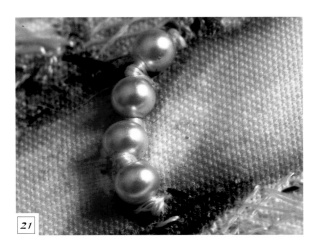

21

Finishing

Use a glue stick and an ear bud. Have a look at the main design and working in sections, decide where you wish to add some glitter on the skirt or elsewhere. Smear some glue on the ear bud and apply the glue to the background. Daub glitter on top of the glue with your finger tip, patting it down gently. Remove the work from the hoop and complete the sections that were not accessible before. Note that the dark shadow on the far right is not embroidered so that the dress has a distinct edge.

Trapunto lady and cat

Trapunto or padded quilting is a fast and simple technique used to enhance embroidery, and well worth trying. **After completing the design,** *a certain section or shape is padded from the back of the work with toy filling, shredded batting or small bits of soft fabric. This forms a raised shape that adds an interesting dimension to the design. An extra layer of fabric the same size as the embroidered block is placed behind the work. It is essential that this (new) backing fabric is as large as the whole embroidered block or else there will be an ugly fold once your work is stretched for framing. The backing cloth should be the same weight as the top layer. Too flexible a fabric, muslin for instance, results in the raised work showing more at the back than the front which defeats the purpose.*

Lie the extra 60 x 60 cm block of fabric flat on a table. Centre the embroidered design on top of this fabric. Place all the layers back into the hoop, pulling all the layers as taut as a drum (especially the back layer). Tighten the hoop and roll and pin the corners out of the way.

Start with the cat: work tiny back or straight stitches along the edge of the shape in 2 strands of black silk thread until the entire shape has been outlined and you are back where you started. The stitches should be so close to the edge they are not noticeable.

Repeat with the left sleeve using 1 strand of Gumnut Aztecs Agate. Start along the white scalloped edge of the sleeve (picture 5), and work along the dark shadow, just above the shoulder (in the darker area) and along the edge at the fluffy part of the blouse. End where you started.

Turn your work to the back where you will see the shapes outlined. Use small, sharp scissors and very carefully cut a slit at the back of the work within the outlined shape. **Be careful** not to cut the stitches. The slit should be just large enough to insert the filling with a hairclip or small nail file. If necessary, cut two or three slits in the shape.

Insert small amounts of filling at a time, right up to the edge of the shape. Be careful not to overdo it. Trapunto should be a subtle enhancement which is not noticeable at first glance. If the background fabric starts to pucker, there is too much filling. Take some out before closing the gap with cross stitch or slip stitch.

Hint

Insert just the point of the scissors and lift the back fabric off the stitches before cutting further.

Swan Cottage 1 by Sung Kim

Licensed by Bentley Licensing Group

Embroidered by Di van Niekerk and Liz Sheffield

Swan Cottage 1

Artist Sung Kim licensed by Bentley Licensing Group
Embroidered by Di van Niekerk T/A Crafts Unlimited
The Red Shed, Ground Floor, V&A Waterfront Shopping Centre, Cape Town
Tel +27 (0)21 671 46074 Fax +27 (0)21 671 4609 pucketty@pixie.co.za

Size of completed image as shown apprivimately 41 x 29 cm

You will need

A good quality image printed on pure cotton fabric available from Di van Niekerk, 60 x 60 cm square.

Threads

Six-strand cotton		
Chameleon 88 Tree Bark	Chameleon Stranded 66 Rustic Brick	Chameleon 83 Summer Sunset
Chameleon 72 Sea Shells	Chameleon 27 Dusky Rose	Chameleon 62 Plumbago
Chameleon 24 Desert Flower	Chameleon 65 Ruby	Chameleon 50 Mango
Chameleon 30 Fern Green	Chameleon 16 Cleomé	Chameleon 20 Coral
Chameleon 57 Olive Branch	Chameleon 33 Forest Shade	Chameleon 49 Mahogany
Chameleon 1 Amber	DMC 934 Very Dark Green	NeedleArts 95 Dark Green

Pure silk		
Eterna 178S	Chameleon 1 Amber	Chameleon 56 Nasturtiums
Chameleon 17 Clotted Cream	Chameleon 8 Black Berry	Chameleon 54 Moss
Chameleon 19 Cobalt	Chameleon 77 Spilt Milk	Chameleon 95 Wisteria
Chameleon 37 Goldrush	Chameleon 34 Fuchsia	Gumnut Aztecs Sapphire MD
Gumnut Aztecs Agate DK	Gumnut Aztecs Amethyst LT	

Like silk		
Chameleon 11 Baobab	Chameleon 66 Rustic Brick	Chameleon 39 Grape Mist
Chameleon 13 Candyfloss	Chameleon 88 Tree Bark	Chameleon 51 Marigold
Chameleon 44 Lavender	Chameleon 25 Desert Sands	Chameleon 97 Green Olives
Chameleon 90 Violets	Chameleon 80 Stormy Seas	Chameleon 69 Scottish Highlands

Perlé	
Chameleon 1 Amber	Chameleon 34 Fuchsia
Chameleon 16 Cleomé	Chameleon 27 Dusky Rose

Velvet cord/Chenille	
Threads for Africa 04 Moss Brown	Threads for Africa 05 Moss Green

Bouclé – fine	
Threads for Africa K14 Forest Green	Threads for Africa K10 Rust Brown
Threads for Africa K12 Grey Moss	Threads for Africa K7 Blue Grey

Rayon chain cord	
Threads For Africa 75 Lime Green	Threads For Africa 1B18 Lime and Cognac

Metallic threads	
DMC 5272 White	Madeira 40 Pink 13
Kreinik Blending Filament 032 Pearl	Kreinik Blending Filament 093 Mauve

Ribbons: Di van Niekerk's hand painted

2 mm silk		
Di v N 25 Dark Pine	Di v N 109 Marigold	Di v N 112 Snap Dragons
Di v N 86 Copper	Di v N 28 Green Pepper	Di v N 24 Light Pine
Di v N 93 Cherry	Di v N 36 Avocado	Di v N 117 Light Kiwi
Di v N 103 Off-White	Di v N 89 Lavender	Di v N 73 Lilac Dazzle
Di v N 41-Mixed Berry		

4 mm silk		
Di v N 109 Marigold	Di v N 20 Fern Brown	Di v N 80 Olive
Di v N 21 Antique Brown	Di v N 110 Wheat	Di v N 34 Pine
Di v N 26 Ivy	Di v N 75 Grape Mist	Di v N 24 Light Pine
Di v N 117 Light Kiwi	Di v N 42 Peony	Di v N 84 Bridesmaid
Di v N 83 Forest Green	Di v N 28 Green Pepper	Di v N 63 Cornflower
Di v N 43 Candyfloss	Di v N 76 Lilac	Di v N 99 Old Gold

7 mm silk		
Di v N 80 Olive	Div N 112 Snap Dragons	Div N 53 Peace Rose

Needles

Mixed pack crewel/embroidery size 5/10	Mixed pack chenille size 18/24	Large tapestry needle or cable needle for the looped stitches

Other

Glitter: white, lavender, and yellow	60 x 60 cm white, light-weight fabric such as muslin, lawn, or polysilk to stabilise the printed fabric and allow for the stitches to be secured as you start and end
60 x 60 cm fabric same weight as the printed design for Trapunto	Embroidery scissors

Stitches

Couching	Detached buttonhole stitch	Detached chain	Feather stitch, single
Fly stitch	French knot rose	French knot	Long and short
Loop stitch	Padded satin stitch	Pistil stitch	Raised stem stitch
Ribbon stitch	Seeding	Spider-web rose	Stem stitch and stem stitch filling
Straight stitch/Stab stitch	Turkey stitch/ Single knotted stitch	Twirled ribbon rose	

Techniques

How to make beautiful trees	Long and short stitch for roofs
Trapunto	Adding light

This peaceful design is the ideal project for the beginner to ribbon embroidery. Simple stitches are used very effectively, and you will learn how to add the necessary texture to create perspective and interest. It shows you how to add the dark shadows – and easy ways to add dimension – and what to do with the trees in the far distance. Leaves and stems are made in many different shades of green, blending beautifully for a natural finish, and different stitches are used in one tree or shrub. This design also teaches you how tree trunks and branches are made and will help you overcome the trepidation everyone feels when filling in a thatched roof. You will be pleasantly surprised to see how easy it is, using an adapted long and short stitch for this purpose.

I will show how to add light in the window and door, how to highlight the water, and where to leave the design uncovered so the completed project is not too busy. Once all the embroidery has been completed, Trapunto is used to add a high relief to some sections such as the flowers in the very front.

Instructions

Start with the roofs of the cottages as this will give you a good idea of the texture you will need for the rest of the design. Embroider the trees behind and in front of the cottages next. The flowers right in the front are embroidered last so they are not damaged by hard-working hands!

Roof on the main cottage

Outline, stitch guides, filling in, detail

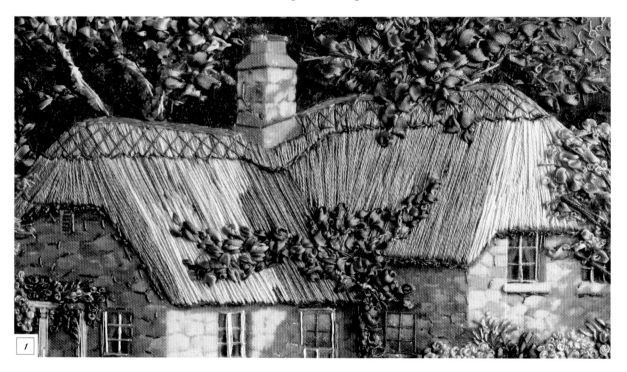

Hint

The correct length of thread to use is the distance from 4 or 5 cm above your elbow to the tip of your fingers – any longer and the thread tends to knot badly.

OUTLINE

Place the printed design and the backing cloth in an 18 inch quilting hoop to prevent distortion. Thread up a medium size (7 or 8) crewel needle with 2 strands of Chameleon 66 stranded cotton and outline the roof in stem stitch. Work along the darkest outer line, along the grooves at the top of the roof and along the

centre where the two thatched sections join (refer to pictures overleaf). Using a stab-stitch style of modern stem stitch gives you more scope for curves. This is a finer stem stitch that doesn't make as thick a line as the traditional one. It is done as follows: bring the needle up from the back of the work along the outline of the shape on the fabric. Make a straight stitch and pull the thread to the back of the work. Re-insert the needle halfway back, bringing the thread to the front again – stab-stitch style. To make a curve, bring the needle out on the outside or widest part of the curve. The smaller the curve, the shorter the stitch. On a straight line it does not matter on which side of the

stitch you bring the needle out, but, if possible, stick to one side throughout the design.

STITCH GUIDES

Still using the same thread, form long straight, back or stem stitches (1 cm lengths for the shorter stitches and up to 3 cm for the longer ones – fewer long stitches have a neater finish than many short ones.) The picture shows where the stitches are placed before filling in the roof. These stitches will ensure that your fill-in stitches all slant the right way.

Hint

Whenever you need to fill in a large area with long and short stitch, whether it is a roof or any other shape, always work stitch guides in straight or stem or back stitch before filling in. Use these guides to ensure uniform stitch direction.

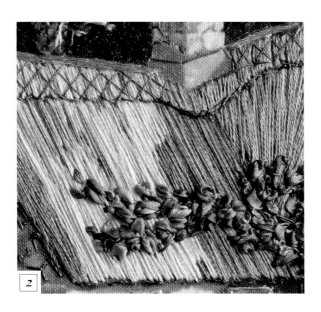

FILLING IN THE ROOF

Use the lightest thread on the light parts and the medium and darker shades on the medium and dark sections, starting with the darkest (refer to picture 1). Thread up with 2 strands of Chameleon 66 stranded cotton and start filling in the darker sections on the roof using a stem stitch filling (vertical rows of stem stitch made close together). Start just below the scalloped top of the roof working downwards and stitch

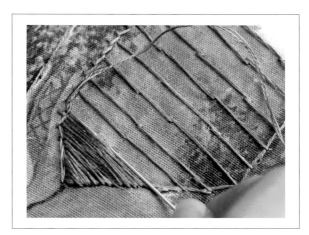

over the embroidered outline along the bottom edge to form a rounded rim. Stitch over the trees and flowers as they are added on top later. Work each row very close to the previous row. Insert the needle so that the stitches are staggered – the needle does not come out where it did for the previous row. Staggering the stitches allows for a smoother finish. Change to Chameleon Stranded 88 every now and then for an

interesting play of colour. I usually work up and down to form the rows. Once the first row is completed, work your way up again (still keeping the needle on the same side) and then down again. For triangular shapes use 3–5 radiating straight stitches and keep coming back in between the previous stitches to fill up the spaces. Once the shape becomes more straight or curved, revert to straight or stem stitch.

For curved shapes remember to bring your needle out on the outside (widest part of the curve). Leave

spaces open when there is a darker or lighter patch and come back later with a darker or lighter shade to fill in. Change to the lighter shades, Chameleon Stranded 83 and 72, and complete the lighter sections of the roof in the same way.

DETAIL

Fill in the top layer of the roof in padded satin stitch (straight stitches made close together). Stitch over the outline (top and bottom) to form a raised layer. Use 2 strands of any of the darker threads (66 or 88), taking care not to pull the stitches too taut. Keep the work pulled tightly in the hoop for a neater, flatter surface.

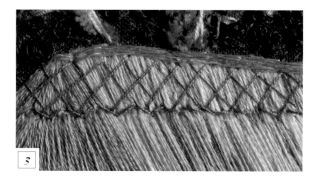

Hint

Very few of my students are happy with their stem-stitch filling until the entire roof has been completed. Don't even look at the stitches until you have completed the section, then go back and fill in any open spaces in stem or straight stitch. Where stitches are skew, embroider on top of them, using the darker lines as a guide. Hold your work an arm's length away to get a better idea of what the roof looks like.

Thread up with 1 strand of Chameleon Stranded 66 or 88 and form the criss-cross pattern over the satin stitched area. First work the bottom rows of slanted straight stitch, then work the top rows slanted in the opposite direction to form the pattern.

Finally thread up with 2 strands of Eterna Silk 178S and embroider the very top edge of this section of roof in horizontal rows of stem stitch (3 or 4 rows close together).

Embroider the dark shadows along the wall under the eaves of the large roof in pistil stitch and straight stitch using 1 strand of Chameleon Like Silk 66. Use the same thread and stem stitch to emphasise the dark join in the centre of the roof.

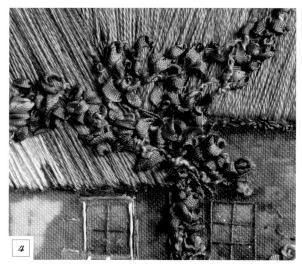

Outline the chimney along the base in straight stitch, still using the same thread. You can also outline some of the chimney's bricks, if you like.

Fill in the top rim of the chimney in satin stitch using 1 strand of Eterna Silk 178S.

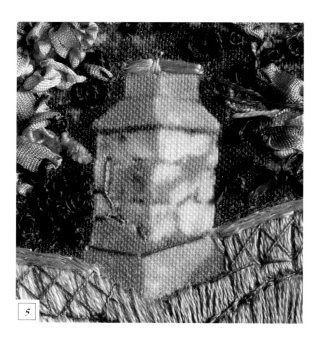

Roof of small cottage

Repeat the steps for the roof of the small cottage on the left. There is no need to form the criss-cross pattern on top of the roof, and the chimney is left unembroidered to create distance.

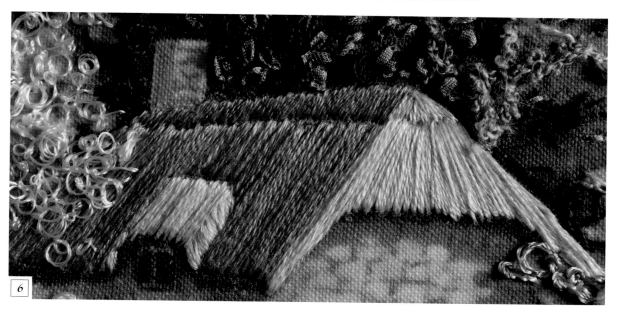

Trees surrounding the main cottage

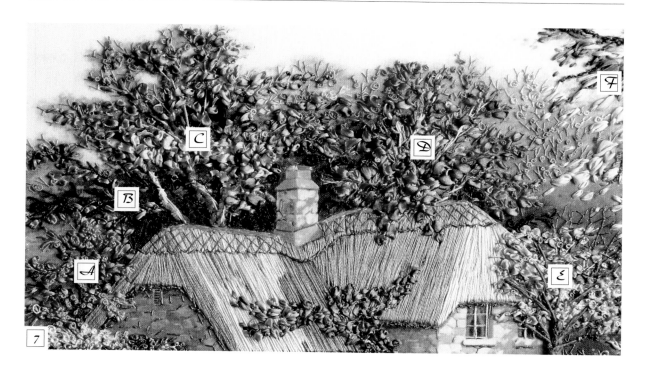

Work the trees one by one or in two's, starting with the branches. Refer to the pictures of the completed embroidery as you go along.

Trees A (pink) and B (green)

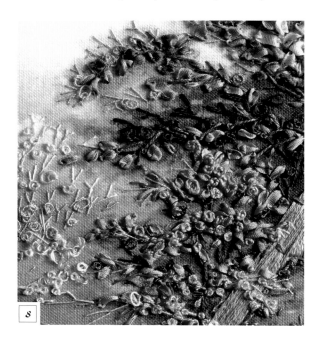

Start with the pink tree (A). Refer to pictures 7 and 8 for detailed lay-out of branches. First work the branches in stem stitch using 2 strands of DMC 934. Add a few French knots (1 wrap) in the same thread for the dark leaves. Use a thinner size 20 or 22 chenille needle and thread up with Di v N 2 mm Silk Ribbon 112 to work the larger pink leaves in fly stitch and tiny straight stitches. Work over the stitched roof, using the picture as a guide for the placement of stitches. Change to a strand of Chameleon Perlé 1 (use the same needle) and form small rust-coloured French knots (1 wrap). Vary the size by making some knots looser than others. This is achieved by not tightening some of the wraps around the needle before taking the thread to the back of the work.

Change to 1 strand of Chameleon Like Silk 13 and make knots as before (1 or 2 wraps). Use pistil stitch to form the longer extended knots.

Use the same thread and fly stitch to form tiny branches in-between and on top of the stitches.

Change to 1 strand of Chameleon Pure Silk 1 and repeat.

Now do the green tree (B). Use 2 strands of DMC 934 and loose French knots to form the very dark green leaves just above tree A and the cottage roof (see picture 7).

Change to 2 strands of NeedleArts Stranded 95 and work the bottle green branches in fly and pistil stitch. Thread a size 20 chenille needle with Di v N 4 mm Silk Ribbon 20 and work the green/brown leaves in ribbon stitch and straight stitch. Change to Di v N 4 mm Silk Ribbon 80 and form the lighter olive green leaves in the same stitches.

Trees C (light green) and D (ginger)

Start with the thick branches of tree C (see picture 9). Thread up with 2 strands of Chameleon Stranded 33 and couch Threads for Africa Velvet cord/Chenille 04 in place to form the branches. You needn't take the cord to the back of the work as you will cover the raw ends with the leaves.

Thread up with 2 strands of Chameleon Stranded 72 and work 1 or 2 rows of stem stitch close together to form the pale cream branches alongside the couched branches. Change to 1 strand of Chameleon Like Silk 51 and use fly stitch to make the tiny golden branches on the outer edge of the tree. Add a few loose French knots between the green leaves (1 wrap). Thread up with 1 strand of Chameleon Like Silk 11 and continue working the fine brown outer branches in fly stitch. Change to 1 strand of Chameleon Like Silk 39 and work the mauve branches on the outer edge of the tree in fly stitch (refer to picture 7). Continue with the mauve branches in same thread and fly stitch, above tree D (picture 10) and towards tree E (picture 11) to form the mauve shadows in the far distance. Add a few mauve French knots in the same thread (1 wrap) to form the round leaves.

Thread up with 1 strand of DMC 934 and use fly stitch and French knots to form the black green shadows above the roof under tree C and between the leaves of trees C and D and above tree E.

COMPLETE TREE C (LIGHT GREEN)

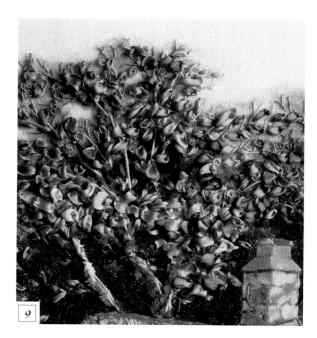

COMPLETE TREE D (GINGER)

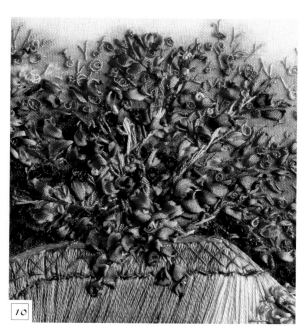

Thread up with Di v N 2 mm Silk Ribbon 20 and use ribbon stitch to form the brown green leaves on tree C (picture 9). Work from the centre branches outwards making some stitches loose and puffed, others almost flat. Change to Di v N 2 mm Silk Ribbon 109 and add the golden leaves in fly stitch and small ribbon stitches. Complete the tree by adding the light green leaves using Di v N 4 mm Silk Ribbon 80 and 34 and the same stitches as before.

Hint

Remember to keep spaces between the leaves and branches. Refer to the pictures often as you work. This space is essential to prevent the trees from becoming too heavy or dominant in a design.

Form the grey branches first using 2 strands of Chameleon Like Silk 66 and long straight stitches. Change to 2 strands of Chameleon Stranded 72 and add the light branches in straight stitch and stem stitch. Work the small rust coloured branches on the tree in fly stitch, alternating Chameleon Like Silk 25 and 11. Use 1 strand of Gumnut Aztecs Agate to add some dark branches in straight stitch and fly stitch.

Change to Di v N 2 mm Silk Ribbon 86 and first work the copper-coloured leaves in fly stitch and straight stitch. Then add the brown leaves in ribbon stitch using Di v N 4 mm Silk Ribbon 21. Make loose, puffed stitches, some over the stitched roof, to create a varied texture.

Finally add the orange branches in tiny fly stitches using 1 strand of Chameleon Pure Silk 56. If you prefer, add more colour by working French knots (1 wrap) between the brown leaves in the same thread.

Complete tree E (lilac)

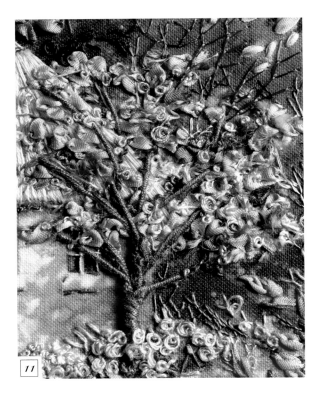

Thread a thick size 18 chenille needle with all 6 strands of Chameleon Like Silk 66 and work the tree trunk in whipped stem and the branches in long straight stitches. (Some of the branches can be added later, once the ribbon leaves have been made so that they appear in front of the leaves.)

Thread up with Di v N 4 mm Silk Ribbon 75 and form the larger leaves in loose, puffed ribbon stitches, working over some of the branches for a natural effect.

Change to 1 strand of Chameleon Stranded 62 and make loose French knots (1 wrap) on top of and between the mauve ribbon stitches. Add some white highlights in the tree using 1 strand of Kreinik Blending Filament 032 and straight stitch and French knots. Finally, embroider the dark branches behind tree E in 1 strand of Chameleon Pure Silk 8 using single feather stitch. Work from the top downwards into tree E.

Thread up with 2 strands of Chameleon Stranded 24 and make loose French knots (1 or 2 wraps) to form the green shrub under the tree. Form the tiny branches at the top in the same colour using fly stitch. Change to 1 strand of Chameleon Pure Silk 8 and add lilac French knots between the green knots to complete the shrub.

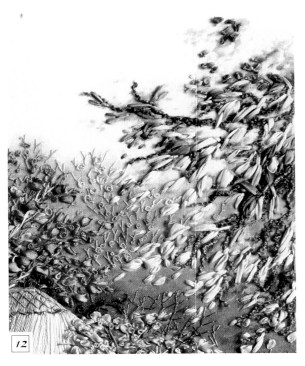

Complete tree F (wheat)

Start with the branches. Thread up a size 18 chenille needle (the thickest in the pack) with Threads for Africa Fine Bouclé K14. Bring the thread from the back of your work and use long straight stitch, stem stitch and fly stitch to form the branches. Keep your tension loose so that the branches appear to be gnarled for a natural effect. If you prefer, use 1 or 2 strands of any matching green thread to couch the branches in place where they are too loose on the fabric.

Thread up with Di v N 2 mm Silk Ribbon 109 and work the thinner wheat-coloured leaves in detached chain, straight stitch and fly stitch. Start at the right margin and work down towards the pink tree, covering some of the branches as you work. Change to Di v N 4 mm Silk Ribbon 109 Marigold alternating with Di v N 4 mm Silk Ribbon 110 and complete the wheat-coloured leaves in the same stitches. Finally add the green leaves in detached chain, using Di v N 4 mm Silk Ribbon 26.

COMPLETE THE PINK TREE

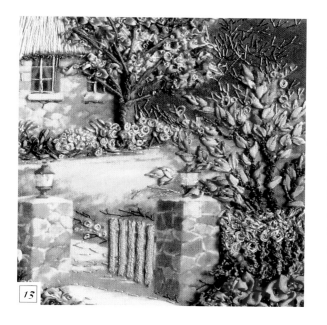

Thread the size 18 chenille needle with Threads for Africa Bouclé K7 and form the branches as you did for tree F. Change to Di v N 4 mm Silk Ribbon 43 and form the pink leaves in detached chain, working from the base of the tree upwards, covering some of the branches as you work.

Thread up with Chameleon Stranded 16 and work the pink branches at the top of the tree in small fly stitches. Add some French knots (1 strand, 1 wrap) in the same pink thread. Change to 1 strand of Gumnut Aztecs Agate DK and work the dark grey branches in fly stitch. Use the same stitch in Gumnut Aztecs Amethyst LT for the pink/grey branches. Use 1 strand of Chameleon Pure Silk 19 and work the blue branches in the background in single feather stitch and fly stitch. Work from the top downwards towards the pink tree.

Gate and paving

Continue with the same amethyst thread in 1 strand and work the gate in raised stem stitch. Pack the rows close together making 2 or 3 extra rows so that the slats are nice and rounded. The slats at the back of the gate can be filled in satin stitch or left unstitched as I have done. Fill in the light-coloured cracks in the paving stones in the same thread using straight stitch and fly stitch. The darker cracks in the shadow at the front are made in 1 strand of Chameleon Stranded or Like Silk 66. Use 1 strand of DMC 934 and fill in the dark green shadow at the base of the right gate post and above the gate in fly stitch or single feather stitch. Change to 1 strand of Chameleon Pure Silk 37 and form loose yellow French knots between the gate and the gate post. The lights on the gate posts are not stitched – glitter will be added at a later stage.

Hint

The stones in the gate posts can be outlined in 1 strand of Gumnut Aztecs Amethyst or Chameleon Stranded 66.

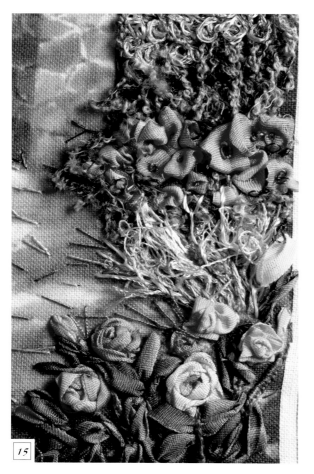

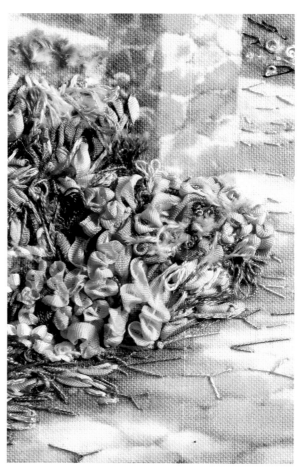

HEDGE

Referring to picture 13, thread a size 20 chenille nee-dle with Threads for Africa Rayon Chain Cord 75 and make loose French knots to form the lime green top part of the hedge. To form the darker green hedge (picture 15) use 1 strand of any matching green thread to couch short vertical lengths of Threads for Africa Fine Bouclé K12 in place, about 3 mm apart. Don't take the Bouclé to the back of the work; allow the raw ends to show for a realistic hedge-like ap-pearance.

PINK FLOWERS UNDER THE HEDGE

Thread the thick size 18 chenille needle with Di v N 7 mm Silk Ribbon 112 and form each flower with loop stitch (use the large tapestry needle or cable needle when forming each loop). The green centre on each loop is formed with a small French knot (1 wrap) in 2 strands of Chameleon Stranded 57. Embroider the pink flowers on the other side of the path in the same way. Work the fluffy green foliage between the pink flowers using 2 strands of Chameleon Stranded 24 and Turkey stitch.

LIGHT-GREEN SHRUB

Refer to picture 15. For the grasslike shrub under the pink flowers, thread a size 20 (medium) chenille needle with Threads for Africa Rayon Chain Cord 75 and make long straight stitches to form the lime green foliage. Thread up with 1 strand of Chameleon Pure Silk 77 and make loose fly stitches on top of the lime green to add highlights.

Hint

If you like, use the same Green Rayon Chain Cord and work a few Turkey stitches to make fluffier grass.

PINK AND PEACH ROSE BUSH

Refer to picture 15. Right in the front, start with the brown stems using 1 strand of Chameleon Like Silk 24 for some and Chameleon Stranded 49 for others. Use detached buttonhole stitch to form loose stems. Work the tiny brown branches at the top of the rose bush in the same threads using fly stitch. Use Di v N 7 mm Silk Ribbon 112 for the pink spider-web roses, changing to Di v N 4 mm Silk Ribbon 84 for the lighter pink roses. The lighter rose bud is made in ribbon stitch using Di v N 7 mm 112 and the darker pink using Di v N 4 mm 84. The peach coloured roses are French knot roses in Di v N 7 mm 53 Silk Ribbon. Work the leaves in Di v N 4 mm Silk Ribbon 83 using detached chain and straight stitch.

Flowers and foliage surrounding small cottage

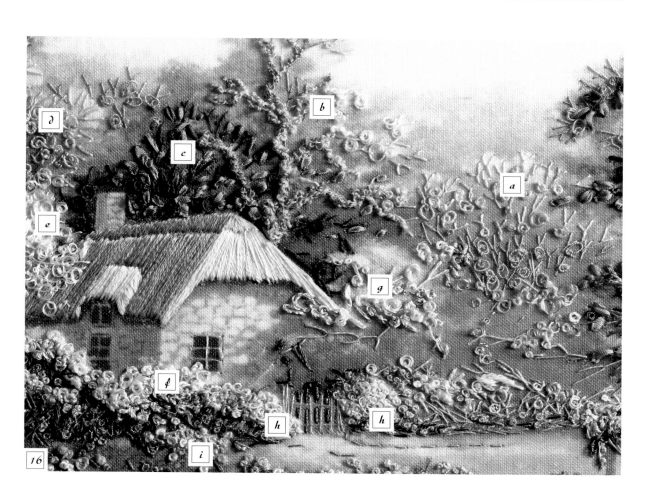

Start with the trees in the far background, working on the right of the cottage.

Pink and mauve background trees (a)

Thread up with 1 strand of Chameleon Stranded 27 and make loose french knots (1 or 2 wraps) and tiny fly stitches to form the pink tree. Change to 1 strand of Chameleon Like Silk 39 and form the mauve tree section in the same way. See pictures 16 and 17.

Yellow tree (g)

Use 1 strand of Threads for Africa Rayon Chain Cord 1B18 and loose French knots (1 wrap) to form the larger leaves of the yellow tree. Change to Chameleon Stranded 24 and work the fine green branches in single feather stitch. Work the golden French knots on the right near towards the flame tree in 1 strand of Chameleon Pure Silk 37. See pictures 16 and 17.

Tall tree (b)

Form the branches first with Threads for Africa Fine Bouclé K10 as before, couching it in place with any matching thread. Change to 1 strand of Chameleon Like Silk 51 and work the fine branches at the tip in fly stitch. Change to 1 strand of Chameleon Pure Silk 17 and form loose French knots (1 or 2 wraps) on the right-hand side of the tree. See pictures 16 and 17.

Gate and hedge on either side (h)

Outline the gate in straight stitch using 1 strand of Kreinik Blending Filament 093. Use the following colours and work the hedge in French knots, using 1 strand of thread throughout: Chameleon Like Silk 13, 44 and 90; Chameleon Stranded 16, 57, 30, 65 and 20; Chameleon Pure Silk 17 using fly stitch, pistil stitch, seeding and straight stitch to add detail. Refer to picture 16 and the main picture on page 64 as a guide. Finally add French knots in between in white metallic thread to highlight the hedge.

Green tree behind roof (c)

Use 1 strand of DMC 934 to form black-green French knots above the cottage roof and between the green leaves. Add tiny fly stitches to form the branches. Change to Di v N 2 mm Silk Ribbon 24 and make tiny straight stitches to form the larger green leaves. Use 1 strand of Chameleon Like Silk 39 and embroider the mauve tree above the greenery in fly stitch and French knots. See pictures 16 and 18.

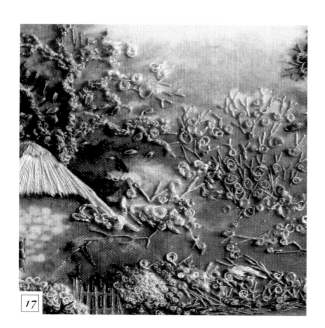

17

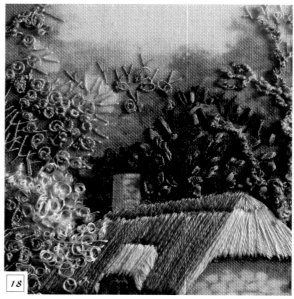

18

Pink and grey trees (d)

Thread up with 1 strand of Chameleon Stranded 16 and form loose French knots as before. Use fly stitch to make the pink branches.

Change to 1 strand of Chameleon Like Silk 69 and work the grey tree in French knots and fly stitch. See pictures 16 and 18.

White and grey tree (e)

Use 1 strand of Chameleon Pure Silk 77 and work the white tree in loose French knots (1 wrap), working over the cottage roof.

Change to Chameleon Like Silk 69 and work the grey section in French knots and fly stitch.

Hint

- *To make very loose, almost looped french knots, all you need to do is **not** to tighten the wraps of thread around the needle before inserting it to the back of the work.*
- *To make a smaller loose knot, make one wrap around the needle, for larger knots wrap two or three times. 1 strand of Rayon or silk thread works best for this stitch.*

Yellow and pink flowering shrubs (f) and window

Use the same colours and stitches as specified for the yellow tree (g) and the hedge (h) and form the flowers, using pictures 16 and 19 as guides. Add the greenery using 1 strand of Chameleon Like Silk 97 and French knots (1 wrap). Finally work the black-green detail using 1 strand of DMC 934 and fly stitch. Outline the window frames in 1 strand of Kreinik Blending Filament 093 and straight stitch and add one or two highlights to the wall. Highlight the flowers in places with French knots in the same mauve metallic thread to add an interesting texture.

Orange and mauve flowers and greenery at the lake (i)

This section too, is embroidered in French knots, straight stitch, pistil stitch and a few fly stitches. The orange flowers are worked in Chameleon Stranded 50; the mauve ones in Chameleon Pure Silk 34 and Like Silk 44. Work the dark green leaves in NeedleArts Stranded 95, then add more green in Chameleon Stranded 33 and Like Silk 97. Use Di v N 2 mm Silk Ribbon 36 and 25 and make a few horizontal straight stitches along the edge of the lake beneath the orange and mauve flowers. Finally add horizontal straight stitches in 1 strand of Chameleon Pure Silk 95.

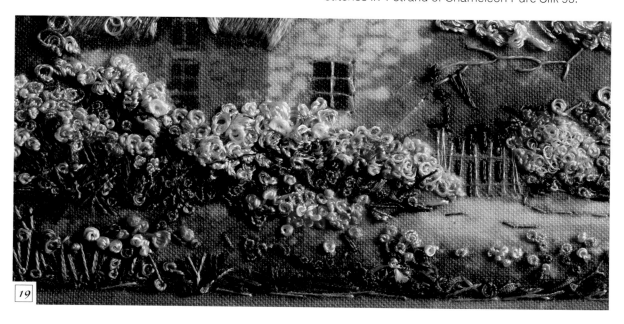

19

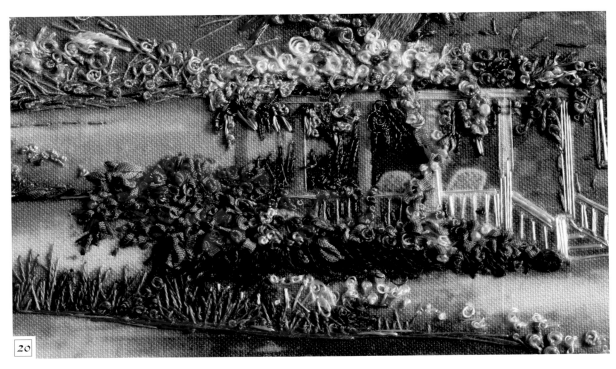

20

Yellow Banksia rose and wisteria

First work the lime green leaves on top of the pergola in French knots (1 wrap) using Threads for Africa Rayon Chain Cord 75. Add the pale yellow roses using 1 strand of Chameleon Like Silk 17 and looser French knots (2 wraps) and tiny fly stitches along the edge. Change to 1 strand of Chameleon Pure Silk 54 and make some green French knots between the yellow ones. Use the same thread and fly stitch to form the finer leaves in the shadows against the wall.

Thread up with 1 strand of Gumnut Aztecs Sapphire MD and make tiny French knots (1 wrap) to form the mauve wisteria hanging from the pergola. Finally work the very dark green leaves under the pergola in 1 strand of Chameleon Like Silk 97 using fly stitch.

Cottage wall, windows and pergola

Change to 1 strand of Gumnut Aztecs Agate DK or Chameleon Like Silk 69 and work the cracks on the cottage wall in straight stitch, see picture 20 and the main picture on page 64. Use 1 strand of Chameleon Pure Silk 77 to outline the window frame in straight stitch. Change to 1 strand of Kreinik Blending Filament 032 and add a few straight stitches next to the white ones to highlight the frame.

Use 1 strand of Chameleon Pure Silk 77 and outline or fill in the pergola poles, patio rail and steps in straight stitch. Alternate with DMC 5272 to create an interesting texture. I have not filled in all the detail as this will make the surface too dense. The chairs too, are not embroidered as they need to recede into the shade of the pergola.

Red climbing rose and yellow shrubs

Refer to picture 20 and thread up with Di v N 2 mm Silk Ribbon 93 and make tiny French knot roses. Change to 1 strand of Chameleon Stranded 65 and add more red French knots between the ribbon roses. Work the yellow shrub at the patio steps in Chameleon Pure Silk 17 in straight stitches and French knots. Add green leaves in Di v N 2 mm Silk Ribbon 25 and 36 using small ribbon stitch, straight stitch, detatched chain and fly stitch. Finally thread up with 1 strand of DMC 934 to form the black-green shadows under the red roses and yellow shrub using fly stitch, and detached chain.

The water's edge

Refer to picture 20. First work the brown edge in 1 strand of Chameleon Like Silk 25 and 88 using horizontal straight stitch with pistil stitch here and there. Add vertical straight and fly stitches in 1 strand Chameleon Like Silk 11 to form the brown grass. The green grass is worked in the same way using 1 strand of 57, 33, 97 and Gumnut Aztecs Agate DK. Thread up with 1 strand of Chameleon Like Silk 77 and work the white flowers in loose French knots (1 wrap). The blue flowers are worked the same way using 1 strand of Chameleon Like Silk 62

Main cottage front section

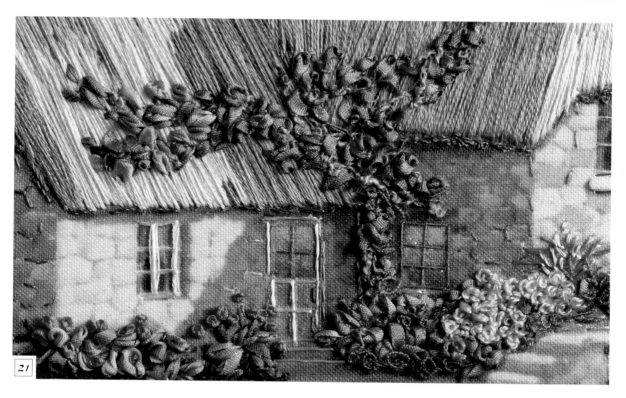

21

Red geraniums

On the left of the front door, embroider the red geranium bed. Thread up with Di v N 2 mm Silk Ribbon 93 and form the red flowers in small tight French knots (1 or 2 wraps). Work the green leaves in Di v N

4 mm Silk Ribbon 80 using detached chain. Add a few more dark shadows in DMC 934 using fly stitch and detached chain. This dark shadow beneath the red flowers creates a definite border that *'anchors'* the geraniums beautifully

Climbing rose on roof

Form the stem and branches first, working over the stitched roof and using picture 21 as a guide for placement. Use Threads for Africa Fine Bouclé K12 and couch in place with a matching thread. You needn't take the Bouclé to the back of the work; simply couch in place and cover the raw edges with the pink roses and leaves later. Work the blue green leaves on the shady part of the roof in ribbon stitch and straight stitch using Di v N 2 mm Silk Ribbon 28. Work from the ground up, covering parts of the stem. Change to Di v N 7 mm Silk Ribbon 80 and work the light olive leaves on the sunny part of the roof in ribbon stitch. Add the pink roses using Di v N 2 mm Silk Ribbon 41 and detached chain and straight stitch.

Pink rose, door and windows

Refer to pictures 21 and 22 and work the rose bush to the right of the front door using Di v N 2 mm Silk Ribbon 41 and detached chain and straight stitch. Outline the door frame and two steps in 1 strand of Chameleon Pure Silk 77 using straight stitches. Add the dark brown outline of the door and steps in 1 strand of Chameleon Pure Silk 66. Do the same for the window on the right of the door. Use 1 strand of Chameleon Pure Silk 77 to outline the window on

the left of the door in straight stitch (see picture 21). Change to 1 strand of Kreinik Blending Filament 032 and add a few straight stitches next to the white ones to highlight the frame of this window.

Corner wall of main cottage

Refer to the main picture on page 64 and picture 23 and note the pink hydrangeas on the right side of the cottage. Use loose French knots (1 strand-1 wrap) for the hydrangeas. Work the pink flowers in Chameleon Perlé 16, 34 and 27, and the blue ones in Chameleon Pure Silk 95. Form the leaves in ribbon stitch and straight stitch using Di v N 2 mm Silk Ribbon 24. Use 2 strands of Chameleon Stranded 24 and long seeding stitches to edge the bed along the cottage up towards tree E.

The orange shrub is worked in 1 strand of Chameleon Pure Silk 56 and fly stitch.

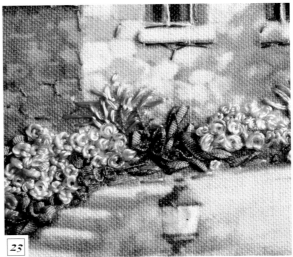
23

Hint

To anchor a bed of flowers in a picture, remember to add a darker green or brown line of stitches (straight stitch, pistil stitch or seeding) beneath the shrubs. This works much in the same way as one would with a flower bed in a garden where a defined edge looks much neater.

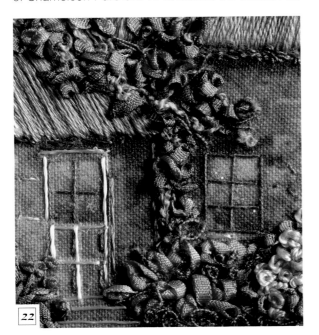
22

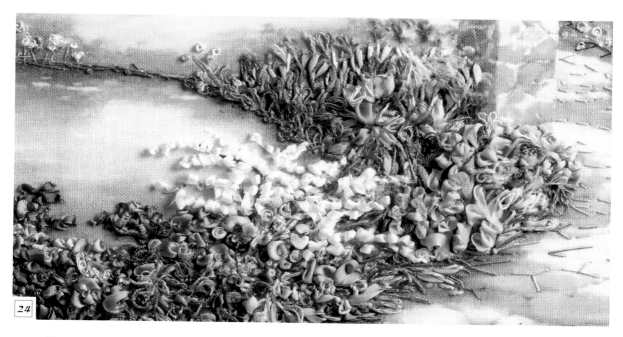

24

RED CANNAS AND WATER'S EDGE

Thread up with 2 strands of Chameleon Stranded 1 and work the red Cannas at the gate post right at the top of picture 24 in single knotted stitch. Cut the loops quite long and fluff to add more texture. The leaves are worked in Di v N 2 mm Silk Ribbon 25 using fly stitch. Change to 1 strand of Chameleon Like Silk 97 and make a few green vertical straight stitches between the ribbon to add the dark shadows. Thread up with Chameleon Like Silk 80 and make long loop stitches to form the emerald green grass along the water's edge. Add a few brown loops in Gumnut Aztecs Agate DK and finally make more dark green loops in 1 strand of Chameleon Stranded 33.

GREEN SHRUB BENEATH THE CANNAS

Thread up with Threads for Africa Rayon Chain 75 and use straight stitch to form the upright leaves. Add a few loose French knots in the same thread. Change to Di v N 7 mm Silk Ribbon 80 and use ribbon stitch and straight stitch to form the large green leaves. Do the same for the olive-coloured leaves along the edge of the path, to the right of the yellow flowers. Fill in with long loop stitches in the darker green threads as you did along the water's edge. Add fly stitch in 2 strands of DMC 934. Use 1 strand of Chameleon Pure Silk 77 and add white highlights in Turkey stitch.

GOLDEN YELLOW FLOWERS

Thread up with 1 strand of Chameleon Pure Silk 37 and use Di v N 4 mm Silk Ribbon 99 to form the gathered ribbon flowers. Make six upright flowers a few millimetres apart, using the gathered leaf method. (See *gathered leaf* on page 116.)

THE WHITE BUSH

Thread up with 2 strands of Chameleon Stranded 49 and form the brown branches in stem and straight stitch. Change to 11 and form the lighter brown branches in the same way. Use Di v N 2 mm Silk Ribbon 103 and loop stitch to form the white blossoms, making larger loops at the base and smaller, flatter

loops towards the tips. Use 1 strand of Chameleon Pure Silk 37 and Stranded 24 and 30 to add the green texture between the white loops in French knots (1 or 2 wraps) and straight stitch.

Work the olive-coloured leaves at the base of the bush in Di v N 7 mm Silk Ribbon 80 and use ribbon stitch and straight stitch. The longer stitches are made in pistil stitch in the same green silk ribbon. Thread up with Di v N 4 mm 117 and make light green loop stitches between the embroidered leaves to add more texture. Add a small light green French knot on top for an interesting effect. Add more French knots in any of the green threads (2 strands, 1 wrap).

Hint

When making the white loops, use a large tapestry needle or cable needle and work from the base of the bush outwards. Make 4 or 5 loops over the needle before removing it to form the next part or adjoining branch.

In front of the lake

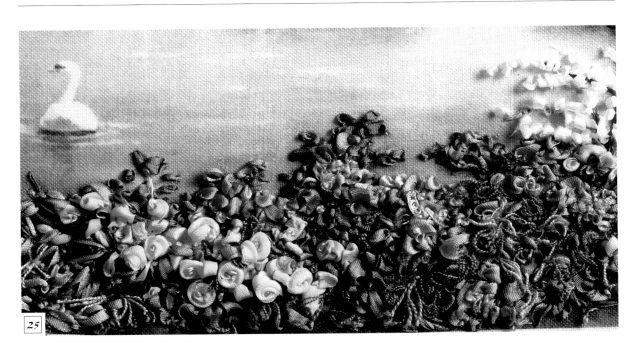

25

PURPLE BUSH

Thread up with Di v N 4 mm Silk Ribbon 24 and work the lighter coloured green leaves first using loose, puffed ribbon stitches. Change to Di v N 4 mm Silk Ribbon 28 and add the emerald green leaves using the same stitch. Thread up with Di v N 4 mm Silk Ribbon 76 and work the lilac-blue petals in loose, puffed ribbon stitch. Then use Di v N 2 mm Silk Ribbon 73 and the same stitch to add the smaller, darker petals at the tips. Change to Chameleon Perlé 16 and add pink French knots (1 wrap) on top of and between the lilac petals. Thread up with 1 strand of Madeira 40 Metallic 13 and add more knots as before. Finally add the fluffy green texture in 1 strand of Chameleon Like Silk 97 and single knotted stitch. Leave the loops quite long. Some stitches are not cut or fluffed, but left as they are for a more realistic, shrubby effect. Use the same thread and loose French knots to add the rounded leaves. Change to Chameleon Stranded 33 and add more knots as before. Finally use 1 strand of Gumnut Aztecs Amethyst LT or Chameleon Like Silk 69 to work the grey foliage in Turkey or single knotted stitch.

Yellow rose bush

Refer to picture 25. Thread up with Di v N 7 mm 53 and make twirled ribbon roses. Carefully make a French knot in 1 strand of Chameleon Pure Silk 56 in the centre of each rose to secure in place. Use the same thread to add more colour in French knots and pistil stitch. Change to Di v N 4 mm Like Silk 117 and make loose, puffed ribbon stitches between the yellow roses. Use Di v N 7 mm Silk Ribbon 80 and add more olive leaves between the roses as before. The darker leaves at the base of the rose bush are worked in detached chain and ribbon stitch in Di v N 4 mm Silk Ribbon 24 and 26. Finally to add the fluffy texture, use 1 strand of Chameleon Like Silk 97 and work leaves in Turkey or single knotted stitch.

Blue flowers

Refer to pictures 25 and 26 and the main picture on page 64. Thread up with 2 strands of NeedleArts Stranded 95 and work a few branches of the bush in stem stitch, straight stitch and fly stitch.

By first forming the branches (even though they are not visible in the painting) it is always easier to get an idea of the direction the leaves and flowers should face on the bush. Thread up with Di v N 4 mm Silk Ribbon 28 and work the leaves in straight stitch. Change to Di v N 2 mm Silk Ribbon 89 and form the pink-blue petals in detached chain, straight stitch and fly stitch. Change to Di v N 4 mm Silk Ribbon 63 and work the blue flowers in the same stitch. Use 1 strand of Gumnut Aztecs Sapphire MD and single knotted stitch to add the fluffy blue leaves. Make some French knots in the same thread. Fill in the spaces between the blue flowers in Chameleon Like Silk 97 and DMC 934 using the same stitches as you did for the purple bush. Work tiny fly stitches at the tips of the bush in Chameleon Like Silk 97. Repeat the entire blue flowers process for the bottom left corner of the design.

Pink rose bush

Form the branches first. Couch Threads for Africa Velvet Cord/Chenille 05 in place with Chameleon Stranded 33. Don't take the cord to the back of your work – the raw edges are covered with leaves or flowers later. Use the same stranded cotton to fill in dark green leaves between the branches in loose French knots. Change to Chameleon Like Silk 97 and make fluffy single knotted stitches or Turkey stitch as for the other shrubs. Use the same thread and fly stitch with long tails to work the smaller branches branching off and over the thick ones.

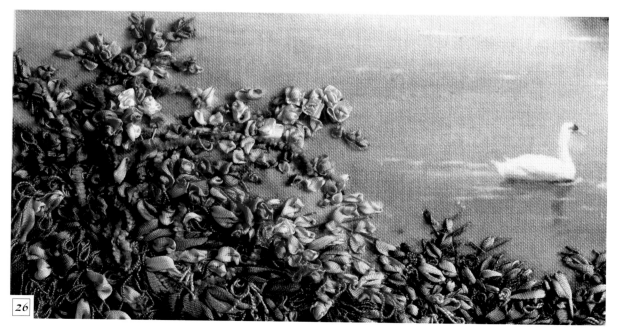

26

Use Di v N 4 mm Silk Ribbon 42 for the darker roses and 84 for the lighter ones and form the flowers using French knot roses, ribbon stitch, and straight stitch. Thread up with 1 strand of Chameleon Stranded 65 and add the finer dark pink detail. Use fly stitch to work the tiny branches. Add French knots and single knotted stitch for more texture.

Work the leaves in ribbon stitch, fly stitch, straight stitch, and detached chain using Di v N 4 mm Silk Ribbon 24 for the darker green at the base of the bush, 26 for the medium green between the pink roses and 117 and Di v N 7mm 80 for the sunny light-green leaves.

27

Finishing touches

GLITTER

Refer to Hydrangeas (Finishing touches page 63) on how to add glitter. Use white and lavender/mauve glitter to highlight the refection on the water, and yellow glitter to add light inside the panes of glass in the door and the window on the right. If you like, use yellow or white glitter on the lanterns on the gate posts.

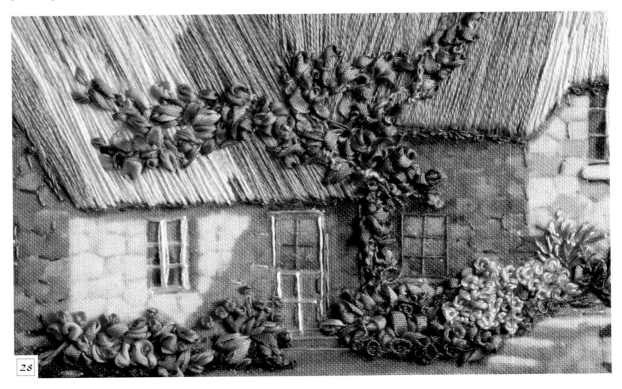

28

Trapunto

Refer to Hydrangeas (lady on sofa) page 00 and Trapunto the following sections to add more dimension to the design:

- The pink bush in front of the gate post left of the path and the yellow flowers in front (picture 29)
- The pink flowers in the bottom right-hand corner (picture 30).

- The yellow rose bush in front of the lake (picture 31).
- The pink rose bush on the left (picture 32).

Encircle each section with a matching thread, use running, stab or back stitch through all 3 layers. Stitch between the flowers and leaves and Trapunto as described on page 63.

29

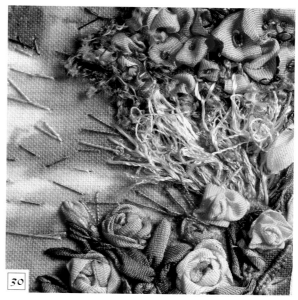

30

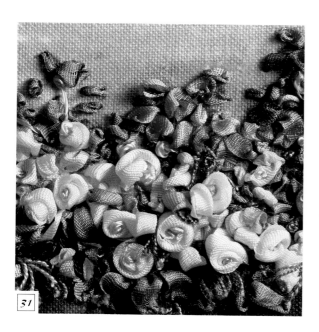

31

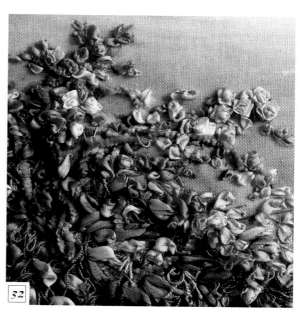

32

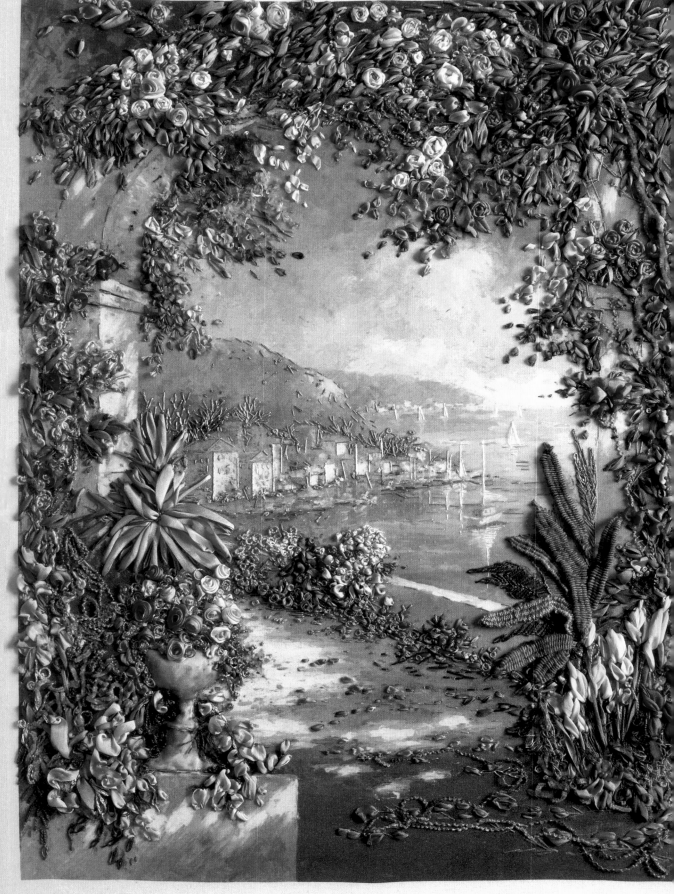

Floral Vista by Jerome Licensed by Bentley Licensing Group Embroidered by Di van Niekerk

Floral Vista

Artist: Jerome. Licensed by Bentley Licensing Group.
Embroidered by Di van Niekerk T/A Crafts Unlimited
The Red Shed, Ground Floor, V&A Waterfront Shopping Centre, Cape Town
Tel +27 (0)21 671 4607/4 Fax +27 (0)21 671 4609 pucketty@pixie.co.za

Size of completed image approximately 40 x29 cm

You will need

A good quality image on pure cotton available from Di van Niekerk
Additional urn printed from the image (only print a small section of the bottom left corner of the image, slightly enlarged – 5 or 10 per cent) available from Di van Niekerk.

Threads

Six-strand cotton		
NeedleArts 95 Dark Green	DMC 934 Dark Green	Chameleon 66 Rustic Brick
Chameleon 59 Peach Blossom	Chameleon 49 Mahogany	Chameleon 57 Olive Branch
Chameleon 6 Autumn Leaves	Chameleon 62 Plumbago	Chameleon 11 Baobab
Chameleon 85 Sweet Melon		

Perlé		
Chameleon 37 Gold Rush	Chameleon 1 Amber	Chameleon 16 Cleomé
Chameleon 33 Forest Shade	NeedleArts 95 Dark Green	

Rayon		
Chameleon 3 Antique Jewels	Chameleon 31 Flame Lily	Chameleon 15 Charcoal
Chameleon 8 Black Berry	Chameleon 56 Nasturtiums	Chameleon 23 Daffodil
Chameleon 37 Gold Rush	NeedleArts 83 Crimson	

Like silk	
Chameleon 57 Olive Branch	Chameleon 33 Forest shade

Velvet cord: Threads for Africa
Green Moss

Rajmahal Art.Silk
No 25 Very Dark Grey

Rayon chain cord
Threads for Africa Rustic

Bouclé – fine: Threads for Africa	
Forest Green	Plum

Bouclé – thick: Threads for Africa
Autumn

Metallic threads	
DMC 5283 Silver	Kreinik Blending Filament 032 Pearl
Kreinik Blending Filament 093 Mauve	Kreinik 006 Blue

Ribbons: Di van Niekerk's hand painted

2 mm silk		
Di v N 47 Tangerine	Di v N 115 Copper Rose	Di v N 59 Orchid

4 mm silk			
Di v N 27 Dark Green Pepper	Di v N 22 Dark Olive	Di v N 28 Light Green Pepper	Di v N 35 Pine
Di v N 34 Salamander	Di v N 36 Avocado	Di v N 83 Forest Green	Di v N 26 Ivy
Di v N 33 Autumn	Di v N 19 Fern	Di v N 60 Red	Di v N 59 Orchid
Di v N 58 Real Red	Di v N 48 Grapefruit	Di v N 46 Coral	Di v N 84 Bridesmaid
Di v N 49 Salsa Orange	Di v N 72 Victorian	Di v N 42 Peony	Di v N 51 Citrus
Di v N 113 Dark Plum	Di v N 77 Antique Cream		

7 mm silk			
Di v N 80 Olive	Di v N 34 Pine	Di v N 60 Red	Di v N 47 Tangerine
Di v N 114 Rosé	Di v N 53 Peace Rose	Di v N 90 Fiery Orange	Di v N 32 Sunny Green
Di v N 76 Lilac	Di v N 73 Lilac Dazzle	Di v N 27 Dark Green pepper	Di v N 29 Sage
Di v N 28 Light Green Pepper	Di v N 116 Post Box Red	Di v N 112 Snap Dragon	Di v N 37 Poinsettia
Di v N 47 Tangerine	Di v N 54 Buttercup	Di v N 33 Autumn	Di v N 38 Dark Rosé
Di v N 58 Red	Di v N 115 Copper Rosé	Di v N 21 Antique Brown	Di v N 91 Flame

6 mm organza		
Di v N 27 Dark Green Pepper	Di v N 25 Dark Pine	Di v N 113 Dark Plum

Needles

Soft sculpture/dolls needle	Chenille size 16, 18, 20, 22
Crewel/Embroidery size 6, 7, 8, 9, 10	Straw/Milliners size 3 and 7

Other

60 x 60 cm white lightweight backing cloth (muslin, polysilk, fine polycotton)	18 inch quilting hoop	Glitter (creamy white, lavender, olive green) and glue stick

Toy filling	Sharp white or silver pencil crayon	Pins

Stitches

Blanket stitch	Chain – detached	Couching	Feather stitch
Fly stitch	Folded ribbon rose	French knot	French knot rose
Gathered leaf	Gathered ribbon flower	Iris stitch	Loop stitch
Picot stitch – closed	Pistil stitch	Ribbon stitch	Ribbon stitch – twisted
Running stitch	Seeding stitch	Spider-web rose	Straight stitch/Stab stitch
Straight stitch – folded	Straight stitch – twisted	Turkey stitch	Whip stitch

Techniques

Building branches and leaves	Making 3-D shapes	Adding glitter

This is the ideal project for anyone who enjoys working with colour and texture. The design uses heaps of ribbons and thread – do not let this deter you. Use the leftover ribbons and threads in future projects.

You will learn how to mix a variety of colours and textures to build a rich intricate design that will enthral friends and family alike! This project teaches you how to create distance in the picture by using tone – light tones in the far distance and dark tones in the foreground. Violet often appears in the far distant hills while shadows are created in the foreground by using dark plum, grey-brown and muddy green. You will also learn how to highlight water and reflections with metallic threads and how to make a three dimensional urn of roses. Finally this design teaches you to balance warm and cold colours, light and shade. You will learn to use yellow greens to lift the design and add sunlight to the picture.

Most important of all, enjoy embroidering your masterpiece!

Instructions

The dark shadows between the flowers and trees are not dark grey or brown as one would think, but dark moss green, forest green and plum. Always try to leave spaces between the foliage, otherwise the design becomes too heavy and full. Note in nature how the black holes are actually empty spaces creating dark shadows.

Branches

Rose branches

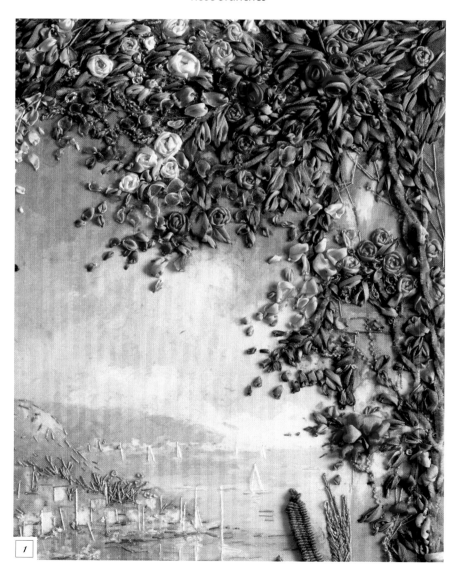

1

Trace the branches onto the main fabric using a sharp white or silver pencil and referring to the main picture on page 88 for placement.

First form the branches of the roses. Start with the climbing roses on the right and top part of the arch.

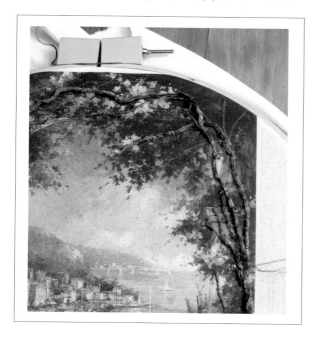

Even if you are unable to see the branches in a design, it is always a good idea to build a framework of branches first, from the ground upwards, so that you can 'grow' the leaves and flowers from the branches in their natural state. The velvet cord and Bouclé is not taken to the back of the work. Lay on top and couch in place.

Couch the moss velvet cord in place as shown. Start at the base of the column just above the red and yellow irises. Use 2 strands of Chameleon Stranded 49 to attach the cord quite loosely with couching stitches about 2-3 cm (1 inch) apart. Then use the finer plum bouclé for thinner branches and couch in place as before. The branches curve from the bottom right corner in the design, right across to the top left hand corner. The raw ends of the cord and Bouclé will be covered with the green leaves in the next step.

To form a thicker branch use another length of velvet cord and use this to whip the first layer of couched cord under and over until a twirled branch is formed. Couch in place evey now and then to secure.

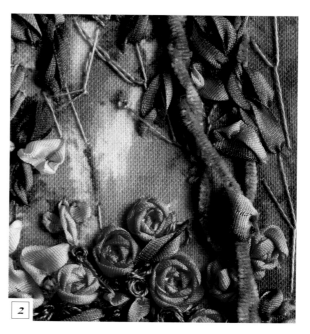

2

Hint

Hold your work an arm's length away or in front of a mirror from time to time to get a better idea of what it looks like. It is almost impossible to judge your work at close glance.

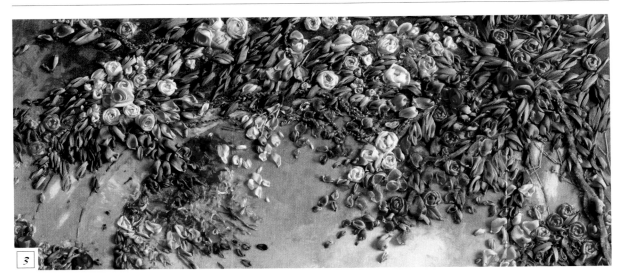

Start working from the bottom right to the top left corner, using pictures 3 and 4 as a guide. With Di v N 4 mm Silk Ribbon 19, work the dark green leaves just above the orange bougainvillea in detached chain and ribbon stitch. Refer to picture 4 and note the direction of the leaves. Change to Chameleon Rayon 31 (1 strand) and add a few detached chain and straight stitches between the green leaves.

Move up the branches. Work the larger leaves in ribbon stitch using Di v N 7 mm Silk Ribbon 27. Change back to Di v N 4 mm Silk Ribbon 19 and complete the section in detached chain. Work the leaves close to the red roses at the top in ribbon stitch using Di v N 6 mm Organza Ribbon 27. The dark green detached chain stitches are worked in Di v N 4 mm Silk Ribbon 35. Form the dark red and brown leaves in detached chain and ribbon stitch using Di v N 4 mm Silk Ribbon 59 and Di v N 7 mm Silk Ribbon 21.

Refer to picture 3 and proceed along the top part of the arch to the coral pink roses, using Di v N 4 mm Silk Ribbon 36 and detached chain with long anchoring stitches. Change to Di v N 7 mm Silk Ribbon 80 and 32 and then work the lighter green leaves in ribbon stitch. This adds the sunlight to the picture.

Next to the coral pink roses, work dark grey leaves falling from the arch onto the blue sky in flat ribbon stitch using Di v N 6 mm Organza Ribbon 113.

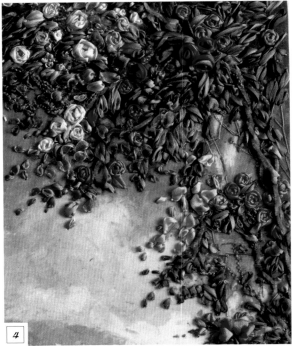

Work the darker green leaves along the end of the branch on the far left, above the red hibiscus in detached chain using Di v N 4 mm Silk Ribbon 22 and 19. Note the direction of the leaves. Add the large, flat leaves just above the bougainvillea on the violet sky in ribbon stitch using Di v N 7 mm Silk Ribbon 27 and 28.

With picture 3 and 4 as your guide, work very fine branches between the leaves in fly stitch with long anchor stitches using 1 strand each of Chameleon Stranded 11 and 66. Finally couch the finer branches (just beneath the arch on the skyline) using the finer plum bouclé as shown in pictures 3, 4 and 5.

Roses

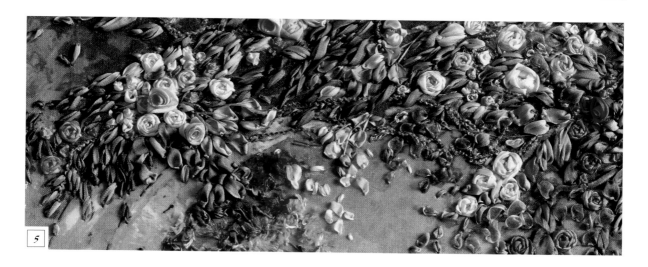

5

Refer to picture 4 and start with the orange roses on the right, just above the bougainvillea. Make spider-web roses in Di v N 4 mm Silk Ribbon 49. Add a few petals in ribbon stitch using Di v N 7 mm Silk Ribbon 90. Make a few loose French knots using 1 strand of DMC 934 to form the green leaves between the roses. Move up and work the dark plum petals in Di v N 4 mm Silk Ribbon 113 in detached chain. Make the dark red spider-web roses using Di v N 4 mm Silk Ribbon 59. Use the same ribbon to add a few petals here and there in ribbon stitch.

Work the larger red folded ribbon roses in Di v N 7 mm Silk Ribbon 58 and 116. The brighter orange detached chain petals are worked in Di v N 4 mm Silk Ribbon 49. To add a spot of colour, work a few orange French knots between the red roses using 1 strand of Chameleon Rayon 56 – refer to pictures 4 and 5 for placement.

Refer to picture 5 and make the coral spider-web roses using Di v N 4 mm Silk Ribbon 48 and 2 mm Silk Ribbon 47 for smaller, flatter roses. Change to Di v N 4 mm Silk Ribbon 84 and make the pink spider-web roses, then work the petals in detached chain and ribbon stitch. Add a few French knot roses in Di v N 4 mm Silk Ribbon 115.

Work the larger tangerine roses at the very top of the picture in Di v N 7 mm Silk Ribbon 47 and folded ribbon roses. The orange roses at the end of the branch are worked as spider-web roses in Di v N 2 mm Silk Ribbon 47 and the brighter orange roses in 4 mm Silk Ribbon 51. Add a few French knots and French knot roses in the same ribbon for the smaller buds and roses. Finally use the Di v N 7 mm Silk Ribbon 112 and add one or two perfect folded roses where the green leaves fall onto the pink bougainvillea in the background.

The backdrop

Mountains, buildings, shoreline, boats and sea

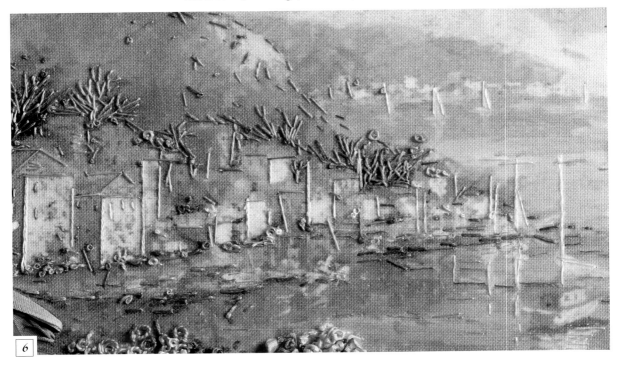

6

MOUNTAIN AND BUILDINGS

Highlight the mountain behind the buildings with seeding in 1 strand of Chameleon Stranded 11. Only a few stitches are made to keep the mountain in the distance.

Hint

To create distance in a picture, use fine, lighter tone thread and small stitches.

Refer to picture 6. Work the trees behind the buildings on the right in 1 strand of Chameleon Stranded 6 using fly stitch. The darker mauve trees on the left are worked in the same stitch. First, use 1 strand of Rajmahal Art.Silk 25, then embroider on top with Chameleon Rayon 3, taking care not to make the trees too thick or heavy so that they will remain in the distance. Use Chameleon Stranded 6 and add a few French knots as shown in picture 6, then change to

1 strand of Chameleon Stranded 66 and add a few more fly stitches just above and between the buildings to create shadows. Give the buildings an edge here and there working straight stitch in 1 strand of Chameleon Stranded 85. Add another straight stitch in silver metallic thread next to this.

SHORELINE, BOATS, AND SEA

Add some texture along the shoreline as shown in picture 6 working pistil stitch, straight stitch and French knots in 1 strand of Chameleon Stranded 11 and 85. 'Anchor' the buildings by using the same colour and stitches along their base. Work straight stitch in Kreinik 006 and 032 metallic thread alongside some of the stitches and on the water's edge to add highlights. Work the boat sails and reflections in straight stitch using Kreinik 032 metallic thread. Highlight some of the darker lines on the sea in straight stitch using Kreinik 093 and 006 metallic thread.

Bougainvillaeas

Adding more colour

BOUGAINVILLAEA BEHIND THE ARCHWAY

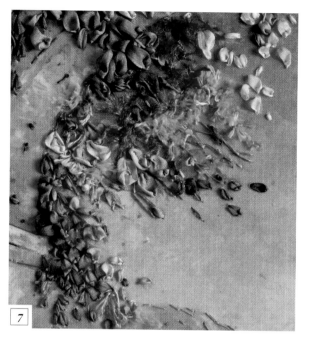

7

Start with the mauve, pink and dark plum leaves. Use short, flat ribbon stitch to create distance. Use Di v N 4 mm Silk Ribbon 84 , 72 and 113, and Di v N 6 mm Organza Ribbon 113 for the larger dark leaves. Refer to picture 7 as a guide when placing colours. Work a few branches in fly and straight stitch using 2 strands of Chameleon Stranded 66. Work Turkey stitch in 2 strands of Chameleon Stranded 59 and 62, Rayon 8, and 1 strand of Perlé 16

Hint

Don't make the Turkey stitch too close together; Turkey stitch needs to be quite sparse to create distance.

Use 1 strand of the same threads mentioned above working fly stitch and small detached chain to add some more colour. Finally, add the larger olive green leaves in ribbon stitch using Di v N 7 mm Silk Ribbon 80. The yellow green adds sunlight to the picture.

BOUGAINVILLAEA AT COLUMN ON RIGHT

Add the green leaves to the completed branches (see picture 8) working detached chain in Di v N 4 mm Silk Ribbon 22. Use the picture as a guide and work the smaller pear-shaped petals in the same stitch using Di v N 4 mm Silk Ribbon 72. Work the smaller red petals at the tip of the copper bougainvillea in detached chain using 1 strand of Chameleon Rayon 31 and add some French knots in the same thread. Make the four flat red-copper petals using ribbon stitch in Di v N 7 mm Silk Ribbon 90 and work loop stitch in the same ribbon to form the larger looped flowers. Add the other flowers working large, loose loop stitches in Di v N 7 mm Silk Ribbon 58, 73 and 76, forming a heavy texture in the foreground. Add shadows working fly stitch and French knots in 1 strand of Chameleon Stranded 66.

Complete this section working French knots in 2 strands of Chameleon Rayon 3 in between to add a bit more colour.

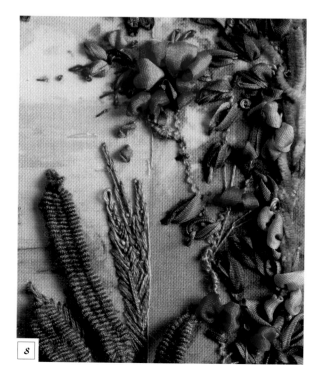

8

Red hibiscus and pink snapdragons

RED HIBISCUS

Work the branches and stems first. Refer back to the main picture. Couch the thicker autumn bouclé thread in place at 1,5 cm (½ inch) intervals, twirling the thread for an interesting effect. Couch the fine plum and/or forest green bouclé thread in place, overlapping the thicker bouclé thread in places to build finer branches for the hibiscus.

Using 1 strand of Chameleon Rayon 31, fill in the finer bits of colour first with loose French knots, pistil stitch and fly stitch. Thread up with Di v N 4 mm Silk Ribbon 19 and make longer, loose detached chains to form the leaves.

Use Di v N 7 mm Silk Ribbon 58 and 1 strand of Chameleon Rayon 37 to form the gathered ribbon flowers (see page 117). Attach to the background with the same thread, using the picture for placement, and make tiny French knots in the centre – one for some and three for other flowers. Use the same thread to add bits of yellow colour in French knots and fly stitch between the green and red until you are happy with the balance of colour and texture.

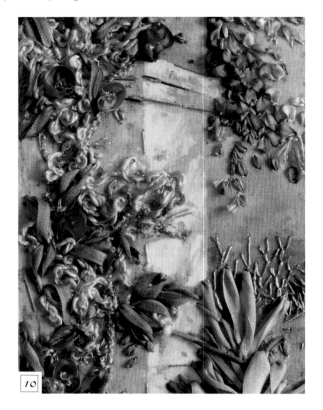

10

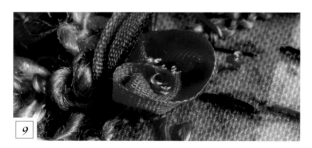

9

PINK SNAPDRAGONS

Work the snapdragons beneath the red hibiscus in Di v N 7 mm Silk Ribbon 112 in loop stitch and loose, puffed ribbon stitch. Thread up with Di v N 4 mm Silk Ribbon 19 and form leaves as you did for the hibiscus. Thread up with 1 strand of Chameleon Perlé 16 and use Turkey stitch to add fluffy flowers between the ribbon stitches. Form loose French knots in the same thread, as shown in picture 11.

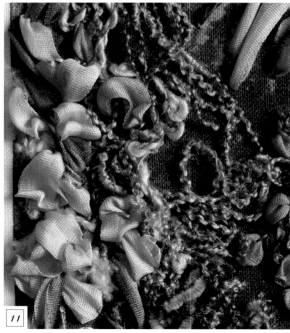

11

Rose urn and surrounds

Making 3-D shapes

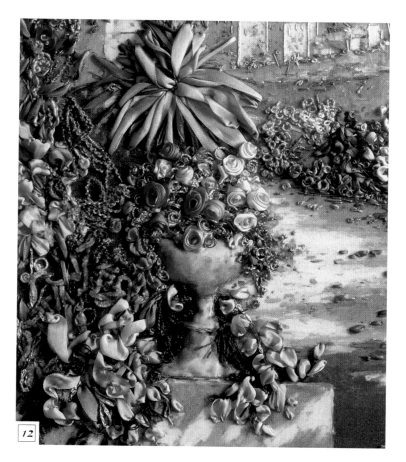

12

THE ROSE URN

Work on the **additional enlarged** urn print. Thread up with 2 strands of Chameleon Stranded 66 and work a line of running stitches 1 mm away from the edge of the printed urn.

Hint

For a larger pot that covers more of the background fabric, stitch 3 or 4 mm away from the top rounded edge that will be covered by the roses and flowers.

Cut out the urn with a pair of sharp embroidery scissors. Turn the hem inwards to the back of the urn as you attach the cut-out to the embroidered design by

stitching it in place with tiny slip stitches. Leave the top of the urn open.

Hint

Where it is difficult to turn the hem in at the sides of the base of the urn, leave the edge as it is and stitch in place with tiny running stitches. The leaves and foliage will eventually cover this.

Fill the urn with toy filling through the opened top to achieve a good, rounded shape. If the fabric puckers, it is too full and you should remove some filling. Close the top of the urn with slip stitch, or leave open as this section will be covered with roses and leaves.

GREEN FOLIAGE ALONGSIDE THE ROSE URN

13

Embroider the foliage next to the urn and the yucca plant behind the urn before making the roses. This prevents the roses from being damaged as you work. Start with the textured vines between the snap dragons and the urn. Following picture 13 as a guide, couch the fine forest green bouclé in place with any green or brown thread. Loosely twirl the bouclé to form curves as you couch it in place. Repeat with the moss green velvet cord, twirling the cord before couching in place.

Form the stems of the leaves on the right of the urn with the rustic rayon chain cord, couch in place with any green thread.

Thread up with Di v N 7 mm Silk Ribbon 34 and embroider some leaves coming off this stem in long, loose ribbon stitches and others in straight stitch and fly stitch.

Work the leaves on the left of the urn in the same ribbon, adding the darker leaves in Di v N 7 mm Silk Ribbon 26 and 20. Form some stitches over the couched cord. Use long ribbon stitches for some of the leaves and a gathered leaf for others. (See page 116 Gathered leaf in the stitch glossary.) Thread up with DMC 934 and work the dark foliage between the vines and at the foot of the urn in fly stitch and long detached chain and Turkey stitch for a fluffier look. Finally add more texture working loose French knots and fly stitch in NeedleArts Perlé 95.

Hints

- *Keep the picture with you and refer to it often as you embroider. The detail in the picture is clearer than that on the cloth.*
- *If you find metallic threads breaking or tearing, change to a needle with a bigger eye. Larger holes are formed in the fabric that allows the thread to pass through easily without tearing the sheen off the thread.*

Yucca above the rose urn

Fill the urn with roses

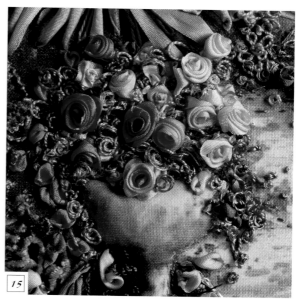

Refer to picture 14 and thread up with Di v N 7 mm Silk Ribbon 20. Starting at the centre point of the bottom plant, make long, loose twisted straight stitches for some of the leaves and twisted ribbon stitch for others. Work the top plant's brown leaves in the same way. Change to Di v N 4 mm Silk Ribbon 25 and add the darker leaves above and to the left the first plant. Thread up with Di v N 2 mm Silk Ribbon 83 and add thin dark leaves on top, some folded straight stitch and others in twisted straight stitch.

Thread up with 1 strand of Chameleon Perlé 1 and add a few French knots (1 or 2 wraps) in the centre of the bottom plant and long detached chain between the lower leaves.

Hint

As a general rule, always remember to complete a flower or plant by adding a few darker French knots in the centre of the shrub.

Make folded ribbon roses in Di v N 7 mm Silk Ribbon 115, 38, 114, 47 and 90. Attach in place with a matching thread (see picture 15 as a guide for placement).

Hint

Folded roses never look good until you have used needle and thread to attach and shape the rose petals. Use tiny stab stitches to 'coax' the roses into shape, inserting the needle in between the folded petals.

The bottom rose on the urn is stitched through all the layers. Use the same ribbons to form the smaller coral pink and orange petals and buds in ribbon stitch and detached chain. Fill the spaces between the roses with loose French knots in 1 strand of Chameleon Perlé 33 and 2 strands of Stranded 57. Add French knots in rustic rayon chain-cord (left over from the stem to the right of the urn) between the green knots. Change to 1 strand of Chameleon Rayon 8 and work the purple flowers hanging out of the urn in loose French knots. Fill in with the same stitch in NeedleArts Rayon 83. Finally work the same stitch in 2 strands of Kreinik 032 metallic thread to add some glitz to the top right flowers in the urn.

The roses and leaves

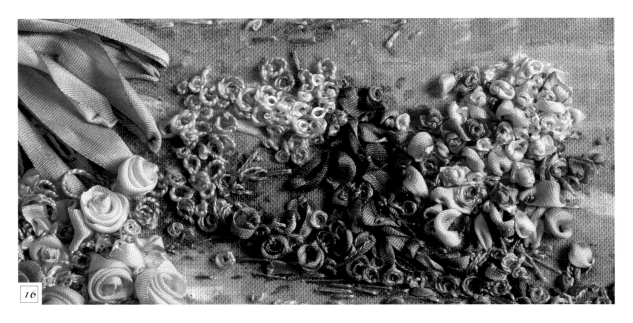

16

GOLDEN BUSH

Work loose French knots (one or two wraps) in Chameleon Perlé 37 to form the gold bush on the balcony wall. Change to any one of the dark green Di v N 4 mm silk ribbons and work the green leaves on the right of the gold bush in detached chain. Add loose French knots (one wrap) near the floor in the same ribbon. Add more knots between the ribbon knots using 1 strand of Chameleon Stranded 57. Change to DMC 934 and add dark shadows in fly stitch.

Hint

To make finer ribbon knots, twist the ribbon before making the knot.

PINK AND GREEN ROSEBUSH

Thread up with Di v N 4 mm Silk Ribbon 42 and make French knot roses to form the darker pink flowers. Change to Di v N 4 mm Silk Ribbon 77 and work the cream roses on the bush in the same stitch. Add more cream flowers working French knots in 2 strands of

Chameleon Stranded 85. Change to Di v N 7 mm Silk Ribbon 33 or 34 and work the larger green leaves in straight stitch and ribbon stitch. Finally work French knots in Kreinik 032 metallic thread to add highlights at the tip of the bush.

RED FLOWERS AT BALCONY WALL

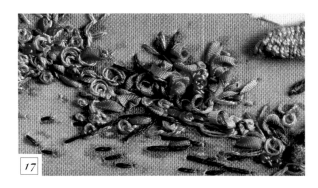

17

Thread up with Di v N 4 mm Silk Ribbon 60 and make the red flowers in straight stitch – some loose and puffed, others pulled taut as you stitch. Work the ribbon leaves in French knots using Di v N 4 mm Silk

Ribbon 19. Twirl the ribbon before making the stitch to form a smaller French knot. Change to one or two strands of Chameleon Stranded 57 and add loose French knots – two or three wraps – between the ribbon leaves. Work fly stitch and feather stitch in one or two strands of Chameleon Like Silk 57 for more texture along the wall, all the way to the gold bush. Change to 2 strands of Chameleon Stranded 57 –and work seeding stitch at the base of all the flowers to form the shadows along the floor. Finally work seeding stitches of about 3 mm long in 2 strands of DMC 934 for the very dark shadows shown in picture 17.

Bottom right corner

Phormium, irises, canna and floor

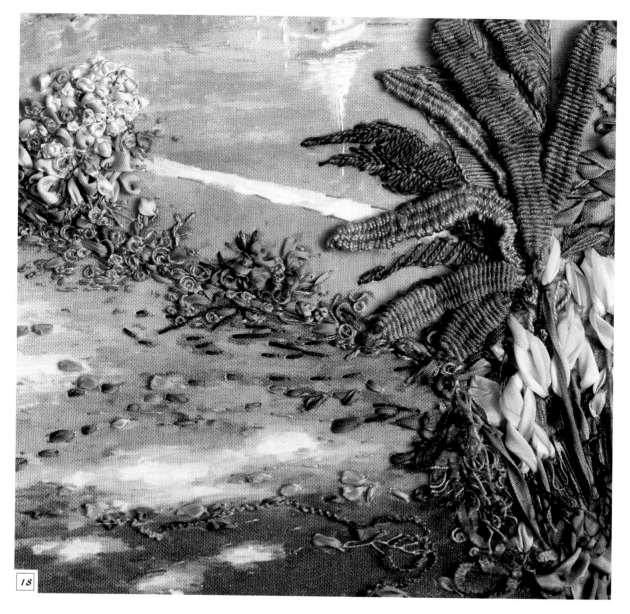

18

Phormium above the yellow irises

The large loose leaves are formed with all 6 strands of Chameleon Like Silk 33. Use picot stitch and a long length (1 to 1,5 m) of thread. This thread makes perfect picot leaves and I highly recommend it for a beautiful effect. Make 7 loose leaves as shown in picture 19. Move these loose leaves out of the way and embroider the remaining leaves directly on the fabric with Chameleon Perlé 33 or NeedleArts Perlé 95. Use blanket stitch for the half-leaves and fly stitch for the full leaves. Work the brown leaves in 2 strands of Chameleon Stranded 57 and fly stitch.

Attach the picot leaves to the background at the tip of each leaf, folding and turning some leaves sideways as shown in picture 19.

Work French knots in 2 strands of DMC 934 to form the shadows at the base of the plant.

Yellow irises and red cannas

Use Di v N 7 mm Silk Ribbon 53 and 54 and form the yellow irises in iris stitch. Use the same ribbon and ribbon stitch for the single buds. Thread up with Di v N 7 mm Silk Ribbon 90 and 58 to embroider the red cannas in iris stitch. Thread up with 1 strand Chameleon Perlé 1 and work Turkey stitch between the cannas and on the right of the yellow irises. Trim the Turkey stitch quite short so that it appears to be behind the flowers.

Change to Di v N 4 mm Silk Ribbon 19 and 20 and work the long green iris stems and leaves in twisted straight stitch. Thread up with 1 strand Chameleon Perlé 1 and make long detached chain and straight stitches between the leaves to add some colour. Use French knots in NeedleArts Perlé 95 to form the dark green shadows between the irises.

Thread up with 2 or 3 strands of Chameleon Like Silk 57 and use Turkey stitch for the foliage on the left of the yellow irises and at the base of the red cannas. Change to two strands of DMC 934 and then to Rajmahal Art.Silk 25 to add the very dark shadows between the flowers and foliage, sill using Turkey stitch.

Make an edge with the moss velvet cord where the flower bed and the floor meet. Twirl the cord for a rounded border; couch in place with matching thread.

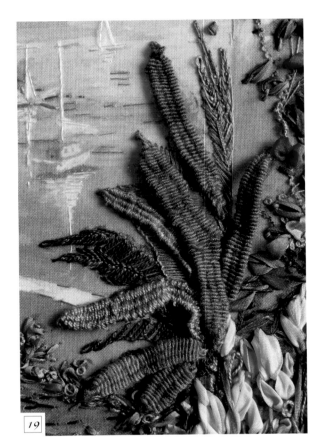

19

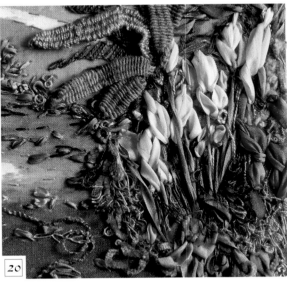

20

Thread up with Di v N 7 mm Silk Ribbon 36 and work the large green leaves hanging over the corded edge of the bed in loose ribbon stitches. Change to any dark green Di v N 4 mm Silk Ribbon and work the dark green leaves nearby in detached chain.

PETALS AND LEAVES ON FLOOR

Work the orange petals on the floor in Di v N 4 mm Silk Ribbon 85 and 87 in a short ribbon stitch. Work the petals in front of the yellow irises in detached chain. Change to Di v N 4 mm Silk Ribbon 19 and repeat for the green leaves. Thread up with DMC 934 and work seeding stitch further back in front of the red flowers at the balcony wall. Change to 2 strands Chameleon Like Silk 57 and work the front leaves in fly stitch. Add more green stems with 2 strands Chameleon Like Silk 33. Use the forest green fine bouclé for the vine further back and the plum for the vine in the front. Couch in place with any matching thread.

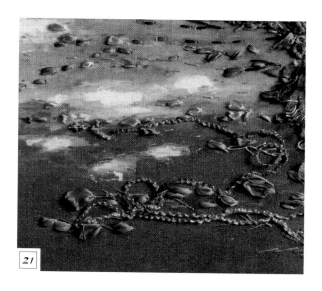

Finishing

COLUMNS

Outline the painted lines on the archway columns and balcony wall in straight stitch using one strand of Chameleon Rayon 15 or Rajmahal Art.Silk 25. Leave spaces between the stitches so that the line is not too dark or heavy. Add a few French knots in the same thread then change to Chameleon Stranded 66 where the lines are lighter.

GLITTER

To add the last touch, apply glitter to the sea, the sunny part of the floor and the sunny part of the columns. Use a cotton bud to apply glue from the gluestick to the section you wish to enhance, for example the sunny floor of the balcony.

Work in sections so that the glue does not dry too quickly. Use a clean cotton bud to pick up some glitter and sprinkle over the glued section, patting the glitter in place with your index finger. Use creamy white for the floor and columns and lavender glitter for the water. Add an olive green glitter on top of the sunny part of the leaves on the column. Allow to dry, then turn the embroidered work upside down and shake off any excess glitter.

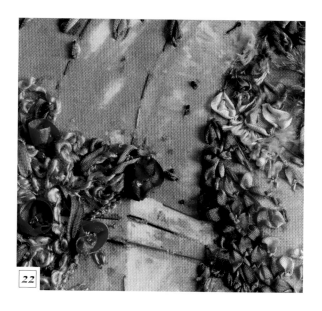

This really adds the final sparkle to your masterpiece!

Hint

With Turkey stitch or single knotted stitch, leave some of the loops uncut. The loops add an interesting texture. Others can be cut and fluffed out to create a woolly effect.

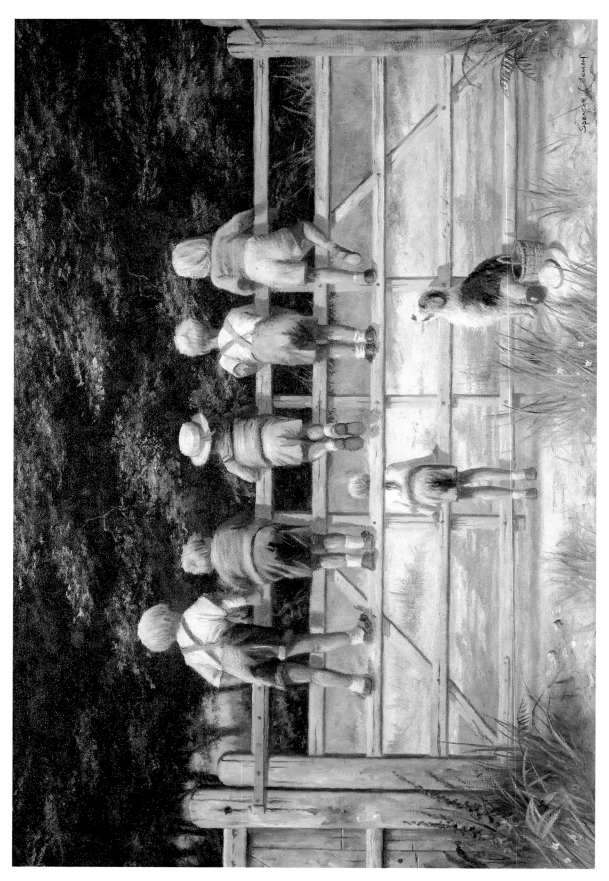

Stitch gallery

Antwerp edging

This stitch is used along the hem of the amber jersey of the boy on the gate. Bring the needle out on the left side of the jersey and insert the needle into the first two threads of the waved loop. Make a buttonhole stitch. Pass the needle behind the buttonhole loop and over the working thread as shown. Proceed along the waved edge for a beautiful ribbed jersey.

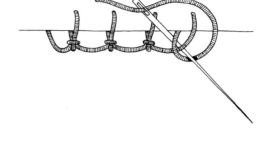

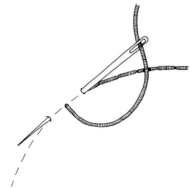

Back stitch

Insert needle from the back of the work and make a small back stitch, taking the needle to the back of the work again. Bring needle to the front, leaving a small gap as shown. Re-insert the needle back where the previous stitch was formed. This stitch is ideal for outlining shapes.

Blanket/Buttonhole stitch

The only difference between blanket and buttonhole stitch is that blanket stitch is worked with larger gaps between the stitches. For buttonhole the stitches are tightly packed, as though you are working a buttonhole on a shirt. Bring the needle and thread out on the outside line. Make a short stitch with the thread under the needle and pull through to form a loop as shown.

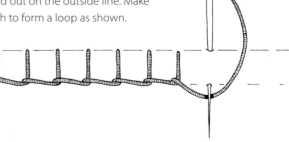

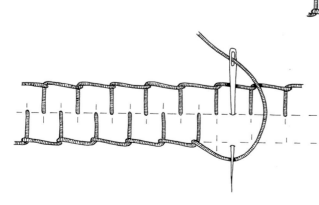

Blanket stitch – double

Two facing rows of blanket stitch with the loops on the outside and the cross stitches interspersed.

Blanket/Buttonhole stitch – detached

This stitch is ideal for branches and stems. First, form a foundation stitch in straight-, stem- or chain stitch. Then form one row of blanket/buttonhole stitch by inserting the needle under the foundation stitch as shown. Only take the needle to the back of the work at the beginning and end of the row. To complete a wired basket handle, insert the needle under the bent wire handle and the working thread to form the detached blanket/buttonhole stitch. To form a knitted, jersey-like effect, see Net filling stitch (page 112) .

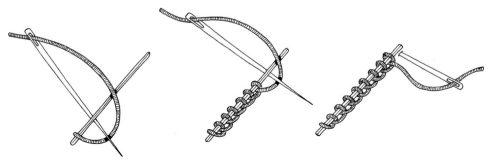

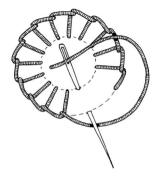

Blanket/Buttonhole wheel

To make a full circle or semi-circle the blanket/buttonhole stitches are formed by inserting the needle back into the centre of the wheel each time. To make a semi-circle only half a wheel is formed. Remember to bring the needle out on the outside when starting the stitch.

Blanket/Buttonhole stitch – closed

The closed blanket/buttonhole stitches are made in groups to form a triangle. The needle is inserted next to the previous stitch as shown.

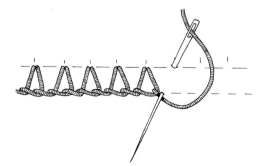

Detached buttonhole

The first row is normal buttonhole (see page 110), but instead of taking the needle to the back of the work, insert it under the foundation stitch (back- or split stitch) and proceed with rows of buttonhole as shown.

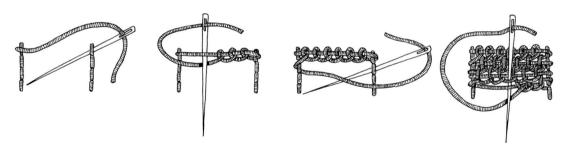

Net filling-stitch

This is the ideal stitch for lacy fillings. Keep a loose tension for a light, lacy feel. Work the first row of loose buttonhole loops over foundation stitches (back - or stem stitch) but instead of taking the thread to the back of the work as you do for open buttonhole stitch, thread the needle under the foundation stitch. Work from right to left, and left to right, back and forth with a loose tension.

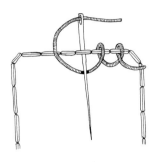
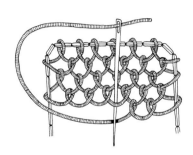

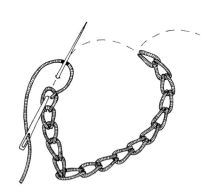

Chain stitch – continuous

Bring needle from the back of the work in the centre or along the edge of the shape. Re-insert where the thread first came out and bring needle out a short distance away. The thread is under the needle each time. Pull to form a chain. Keep inserting the needle inside each chain as shown. To end off, insert the needle to the back of the work just on the outside of the chain.

Chain – detached/Lazy Daisy with thread

A single chain is made at a time, to form interesting leaves and flowers. Each detached chain is anchored by taking the needle to the back of the work every time as shown. To form a flower, make five or six detached chains and add a bead or French knot in the centre.

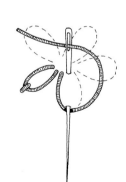

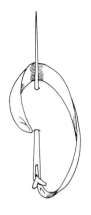

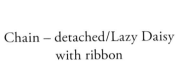

Chain – detached/Lazy Daisy with ribbon

Make the stitch as you would with thread, but keep the ribbon loose to form a realistic leaf or flower.

Couching

To form interesting stems and branches, couch thicker yarns in place. This is a good stitch to use when the laid yarn is too thick to take to the back of the work. Use 1 or 2 strands of matching thread to couch the yarn in place as shown. The raw ends of the laid yarn can be covered with leaves or flowers, or left uncovered for a realistic finish.

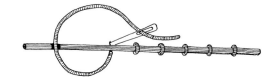

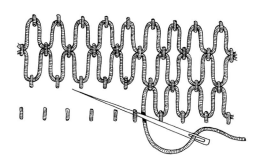

Cloud filling-stitch

This is a good filling stitch with a lacy appearance. Work tiny stab stitches as shown and weave the thread through the foundation to form an interesting pattern.

Covering a bead

Use 2 or 4 mm silk ribbon on a size 20 or 22 chenille needle. To make a round ball, use a round bead with a large enough hole for the needle to pass through. Insert the needle and ribbon inside the hole of the bead and leave a tail about 5 cm in length. Cover the bead by overlapping the previous stitch by 1 or 2 mm. To end off, prick the first tail and cut off a 5 cm length so that there are now 2 tails. Insert both tails in a size 18 chenille needle. Insert the needle from the front to the back of the embroidery; remove tails from the needle and make a few knots one on top of each other with the tails to secure the bead to the fabric. Use 1 or 2 strands of thread to cover smaller beads.

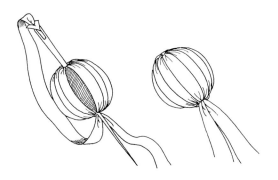

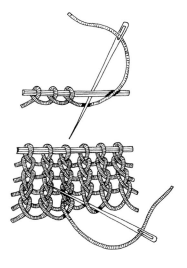

Ceylon stitch

This stitch is similar to net filling-stitch or open buttonhole stitch but note how the needle is inserted under both the threads of the loop to form a knitted shape.

Crested chain stitch

This stitch makes an interesting border. The needle is inserted under the thread as shown, and then brought out over the working thread.

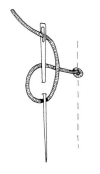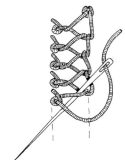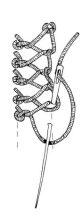

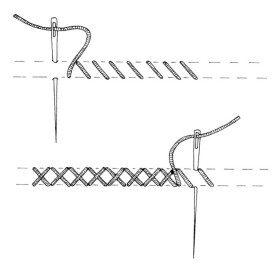

Cross stitch

Make the first row of half-crosses, and complete as shown. Make sure the upper halves of the crosses lie in the same direction.

Feather stitch

Feather stitch is ideal for shrubs and hedges and fills up the detail very quickly. Best used with finer threads for these designs, it is worked the same way as fly stitch (see page 115), but instead of making a single stitch, insert the needle to the right then to the left, as shown. Remember to keep the thread under the needle each time a stitch is formed.

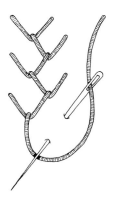

Feather stitch – single

Single feather stitch is made the same way as feather stitch, but the needle is inserted to the right (or left) each time. This stitch is ideal for finer branches that do not spread outwards.

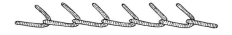

Fly stitch

Fly stitch is worked the same way as chain stitch, but insert the needle a short distance away from where the first stitch emerged, as shown. Anchor the stitch by taking the needle to the back of the work each time. Longer anchoring stitches can be made in varying lengths for an interesting effect. This stitch is ideal for fine branches and stems.

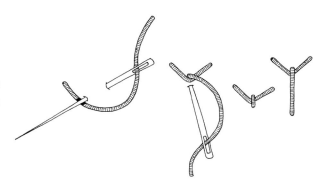

French knot

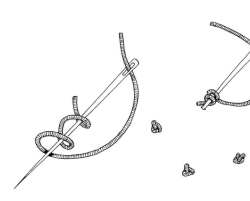

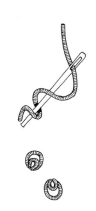

French knots are ideal filling stitches for these designs. For finer detail use 1 strand of thread and wrap the thread once or twice around the needle. For a heavier texture, use a thicker thread or 2 or 4 mm silk ribbon and wrap once, twice or three times around the needle. To form loose, frilly knots, be sure not to tighten the wraps around the needle before taking the needle to the back of the work. The more slippery silk and rayon threads are ideal for loose knots.

French knot rose

The French knot rose made with 2, 4 or 7 mm silk ribbon and 6 mm organza is where smaller roses are required. Wrap the ribbon once or twice around the needle as if making a French knot, but instead of inserting the needle back into the fabric, gather the ribbon for 2 or 3 cm or more. The gathered stitches are about 3 mm apart. Then insert the needle to the back as shown, gently pulling the ribbon to the back to form a beautiful rose.

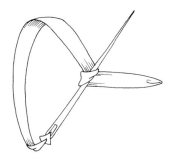

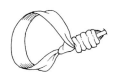

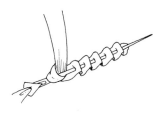

Folded ribbon rose

Folded ribbon roses are made separately
as illustrated step by step, and then
attached to the background. Use needle
and thread (insert the needle between
the folded petals) and tidy or re-shape
the rose. Ribbon stitch leaves made
underneath the folded rose will lift the
outer petals and enhance the rose. Silk
ribbon of 7 and 13 mm are ideal for the
designs in this book.

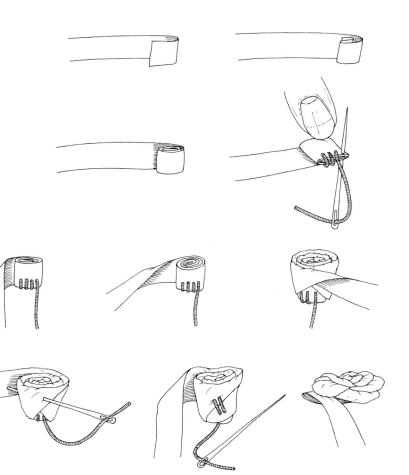

Gathered leaves

Gathered leaves work well with ribbon when larger leaves are required.
The 4 and 7 mm silk or 6 mm organza ribbons are ideal for the designs in
this book. Use 1 or 2 strands of matching thread and gather the required
length of ribbon (usually 3 or 4 cm long) as shown. Pull the thread to
gather the leaf and insert both needles to the back of the work.

Gathered ribbon flower

The gathered ribbon flower makes a good cup shaped flower. Use 7 mm silk or 6 mm organza ribbon for medium size flowers and 13 or 15 mm silk or organza for larger flowers. This flower is 'coaxed' into shape when attached to the background. The French knots worked inside the circle after the shape has been attached determine what flower it will become. Golden, mustard-coloured knots make hibiscus or old-fashioned roses and green knots are ideal for petunias.

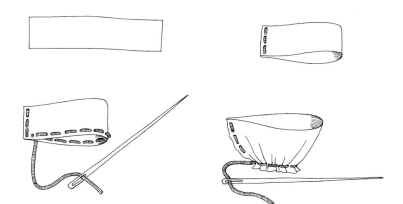

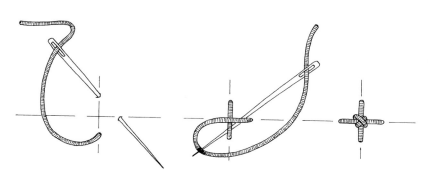

Four-legged knot stitch

This is an interesting filling stitch for shirts or jerseys. Use 1 or 2 strands of thread so the detail is not too heavy.

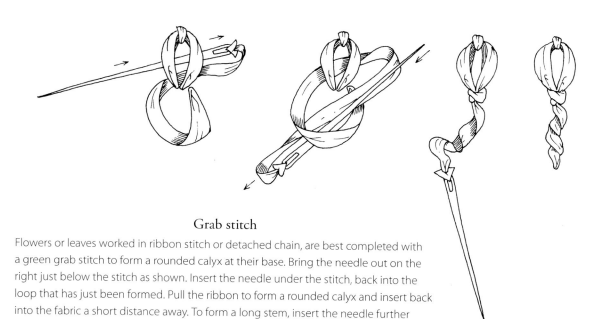

Grab stitch

Flowers or leaves worked in ribbon stitch or detached chain, are best completed with a green grab stitch to form a rounded calyx at their base. Bring the needle out on the right just below the stitch as shown. Insert the needle under the stitch, back into the loop that has just been formed. Pull the ribbon to form a rounded calyx and insert back into the fabric a short distance away. To form a long stem, insert the needle further away, twisting the ribbon to make a thinner stem.

Iris Stitch

Use 7 mm silk or 6 mm organza ribbon for the best iris stitches. Small irises in the far distance can be made the same way in 2 or 4 mm silk ribbon, or 3 mm organza.

First make a loose/puffed detached chain stitch taking the needle to the back as usual. Bring the needle up to the right of this stitch a short distance away. Insert the needle (blunt end is best) under the chain and take the needle to the back as shown. Remember to keep a loose tension – the stitches are loose and puffed for this flower.

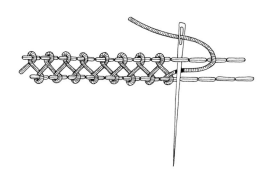

Interlacing band stitch

First, make two parallel rows of back stitch to form the foundation rows. Make sure that the stitches in these rows do not align. Then form the lacy stitch as shown.

Knotted chain stitch

This stitch makes good borders. The needle is threaded under the stitch that has just been formed, and the working thread is left loose so that the needle can be inserted under the loop and over the thread. A knot is now formed so that the next stitch can be made.

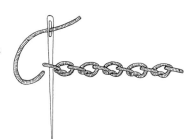
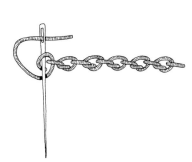

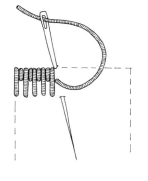
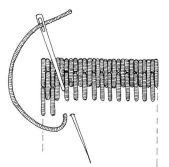

Long and short stitch

This is a good filling stitch. Work with one strand for the best results. When working with 2 strands, separate the threads before inserting them into a needle. This way, the threads are smooth and untwisted. When filling in a roof, it is best to make longer stitches of 2 or 2,5 cm in length. (See Stem-stitch filling on page 123 as an alternative for long and short stitch.)

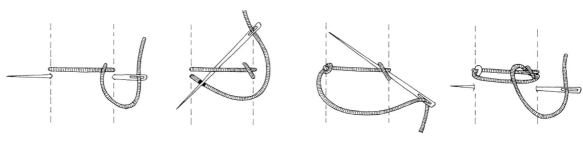

Ladder stitch

This is ideal for filling shapes of varied widths. Follow the diagram and note that the needle passes through two stitches at each end to form a plaited edge.

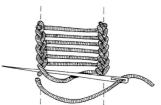

Loop stitch

Loop stitch can be worked in either ribbon or thread. To make a soft, rounded loop with ribbon, do not lift the stabilizing needle or toothpick off the fabric. Make several loops before removing the stabilizing needle to make more loops. When using thread for loop stitch, pull the stabilizing needle until the loop is the required length. Hold the loop in place by pulling the stabilizing needle up or downwards and make 3 or 4 loops before removing the stabilizer from the first few loops.

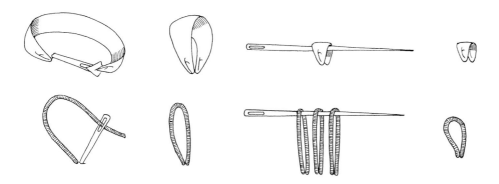

Long and short buttonhole stitch

This stitch is ideal for stumpwork leaves as a smooth, raised edge is formed that allows the shape to be cut out quite safely. Fill in the empty spaces with long and short stitch.

Overcast stitch

Use this stitch for covering a couched wire or any object that needs to be attached to the design, such as a necklace or bracelet. Angle the needle as shown and re-insert from the back at the same angle. Work stab-stitch style, taking the thread to the back each time, so that the overcast stitch fits snugly against the object attached.

Open buttonhole stitch

This stitch is similar to Ceylon stitch but note that the needle is inserted through the one looped strand of the previous row. Stitches are worked over an outline row of back or stem stitch. Keep a loose tension throughout and take the thread to the back of the work as each row is completed. Work back and forth, left to right, right to left, working stitches into the previous row of loops as shown.

Padded satin stitch

Use for shapes that need a neat, rounded edge. First outline the shape in split-, stem- or back stitch. Then cover with satin stitch, close together stitching over the outlined edge for a padded effect.

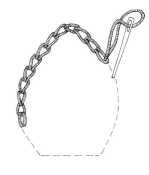
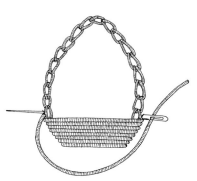

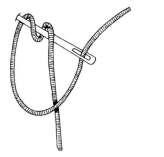

Pistil stitch

An elongated or extended French knot. Make 1, 2 or 3 wraps and instead of inserting the needle close to where the thread emerged, insert it a few millimetres or even centimetres away. Ideal for long grass or stems and for edging under a roof where French knots would have too heavy a texture.

Picot stitch – closed

This is perfect for long, loose leaves and the best thread for this stitch is Chameleon Like Silk or perlé no 8. To make a fatter leaf, keep the tension loose as you weave in and out of the foundation stitches. Remember to use a long length of thread for long leaves. The soft sculpture/doll's needle (about 13 cm long) that is used for making teddy bears is the only needle to use for long leaves.

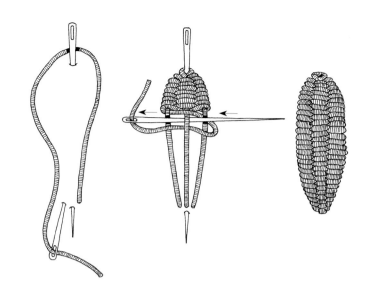

Raised stem stitch

Use for gateposts or any woody texture. The foundation stitches need to be quite taut, the same length and equidistant throughout. Bring the needle out along the edge and thread over and under each foundation stitch. Take care not to pull the thread too tight. The needle faces the emerging thread each time and the long looped thread faces downwards every time. For an interesting variation, skip one foundation stitch inserting the needle under every second stitch. A definite pattern is prevented by alternating each row. This is a much faster method.

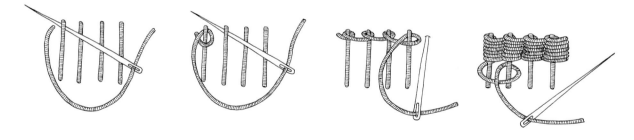

Ribbon Stitch

Not surprisingly, this is probably the stitch used the most in ribbon embroidery. It makes beautiful leaves and buds. Keep the ribbon quite loose, as flat ribbon stitches tend to spoil a design. When inserting the needle into the ribbon, there are three choices. Insert the needle just to the left of the ribbon edge, and the leaf will curl up to the left. Insert the needle to the right and the leaf curls up to the right. Insert it in the centre and a different shape is made. To help make loose, puffed ribbon stitches, push the ribbon up slightly with the needle as it is inserted into the ribbon or use a thick tapestry needle or smooth toothpick under the ribbon.

Ribbon stitch – twisted

Twisted ribbon stitch makes interesting stems and long leaves and is useful when the ribbon needs to be thinner than it is. Twist the ribbon before inserting the needle.

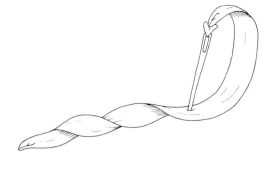

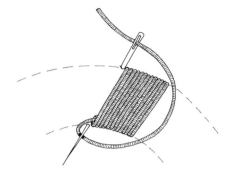

Rope stitch

This stitch works well for shapes that require a raised edge. Remember to keep the working thread under the needle as shown.

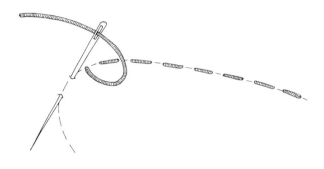

Running stitch

This stitch can be made in thread or ribbon. As the fabric is stretched taut in the hoop, you may find it easier to take the needle and thread to the back of the work in a stab stitch style before inserting it to the front again .

Slip stitch

Split stitch is used to attach shapes to the background for a three-dimensional appearance. Use 2 strands of matching thread – stranded cotton, silk or rayon.

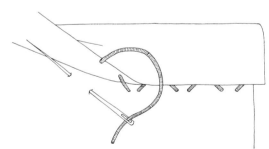

Stem stitch

A slight variation on the traditional stem stitch results in a finer stem stitch which works well for these designs. Instead of making the traditional slanted stitches, insert the needle along an imaginary or drawn line as shown. Longer stitches (1 to 3 cm in length) are also used for a smoother texture.

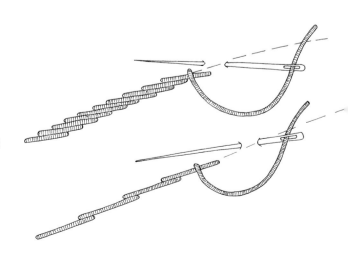

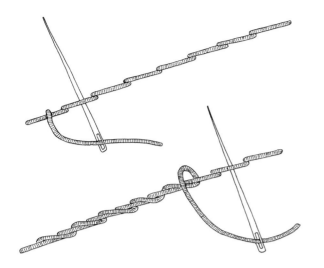

Stem stitch – whipped

For a thicker stem or outline the stem stitch can be whipped by inserting the needle under and over the foundation row of stem stitch. The needle is not taken to the back of the work with this stitch. I find it easier to use the blunt end of the needle for this stitch. Back-, running-, chain-, or split stitch can be whipped in the same way.

Stem stitch filling

Stem stitch filling is row upon row of closely packed stem stitch. Do not make the stitches too short – preferably use stitch lengths of 2 or 3 cm for a smooth finish and alternate each row as shown. This is the stitch used for the cottage roofs, which is a much easier technique than long and short.

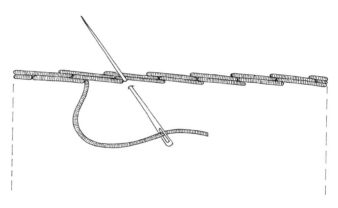

Spider-web rose

This technique (in 2, 4 or 7 mm silk ribbon or 6 mm organza ribbon) is ideal to create beautiful, realistic roses. Keep the tension quite loose for spider-web roses. To make perfect petals, twist the ribbon before threading it under the foundation stitches. Any of the foundation threads that are showing on the side of the completed rose can be covered with leaves later. Stop weaving the ribbon as soon as some of the five foundation stitches start disappearing. The more you weave, the more the rose will bunch up to form a tightly closed shape that is not at all appealing!

Seeding stitch

Seeding is one of the best stitches for shadows. The stitches can be made in varying lengths up to 1 cm in length or even longer. Use 1 or 2 strands of stranded cotton, silk or Like Silk for these designs. Tiny stitches can be made to create a rough texture for stones or grass. Keep the fabric stretched taut in the hoop for this stitch.

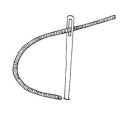 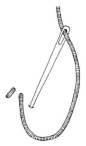

Straight or stab stitch

Straight or stab stitches are worked in different lengths in either thread or ribbon and are ideal for long grass and stems. The stitches should not be so loose that they spoil the design and need to be made with the fabric stretched quite taut on a hoop. These stitches are made stab-stitch style where the needle and thread are taken to the back of the work before being brought to the front again.

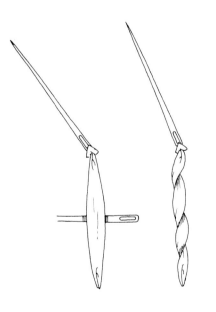

Straight stitch – loose

To form soft, loose straight stitches, insert a tapestry needle or smooth toothpick under the ribbon before inserting the threaded needle to the back of the work. Try to keep a loose tension for stitches made in ribbon.

Straight stitch – twisted

Twisted straight stitch works well with ribbon. To form long blades of grass or for an interesting variation on leaves, twist the ribbon before inserting the needle to the back of the work. Every now and then allow the ribbon to untwist by holding your work upside down. Re-twist for a softer look.

Straight stitch – folded

Folded straight stitch is ideal for bent stems or grass. The ribbon can either be twisted as shown or kept flat. Insert the needle back where the fold needs to be, and stitch over the ribbon as shown. This stitch, too, needs to be quite loose.

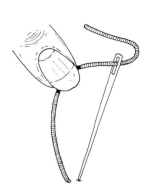
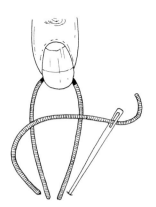
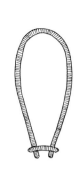

Single-knotted stitch.

This stitch is used to add a fluffy or looped texture between leaves. Make a loop as shown, hold the loop in place with your finger or use a large tapestry needle, and bring the needle out very close to the left of the loop. Insert it back on the right as shown, and anchor it to the fabric before proceeding with the next stitch. Pull the anchoring stitch quite taut so that a thin, elongated loop is formed. Leave some loops uncut for an interesting texture and cut others before fluffing. Always use embroidery scissors with sharp points.

Turkey stitch

Turkey stitch is a wonderfully versatile stitch to add a fluffy texture to a design. An adapted stitch is illustrated here where a long looped thread is anchored to the background with a small straight/stab stitch. Make stitches close together when filling in shapes like a dog or a cat and further apart for filling in foliage or clothing. When cutting the loops before fluffing the thread, insert the sharp point of the embroidery scissors and pull the stitch towards you or up or downwards before cutting. This makes the loop lie in the right direction. Fluff with the sharp point of the scissors. To ensure a smooth velvety texture for animals, ensure the anchoring stitch is as close to the fabric as possible (see single-knotted stitch overleaf).

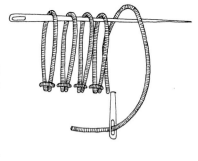
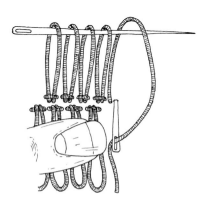

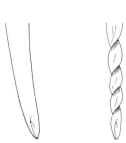

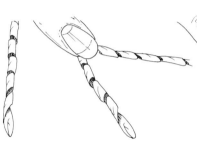
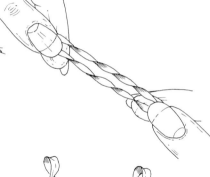

Twirled ribbon rose

This stitch makes an exceptionally realistic rose. Use 4 or ideally 7 mm silk ribbon and follow the diagram. Once the ribbon has been twirled to form a cylindrical tube, hold it in place about 5 cm away from where the ribbon emerges from the fabric. Bend and bring the two lengths together along the fabric background. Let go of the ribbon and allow it to twirl together. Insert the needle into the background about 1 or 2 mm away from the emerged ribbon and, holding the twirled length of ribbon, gently pull the ribbon to the back. Only let go once most of the ribbon is almost pulled through to the back. Once the rose is made, you will need to anchor it with tiny French knots or stab stitches in the centre to prevent it from unraveling.

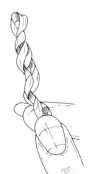
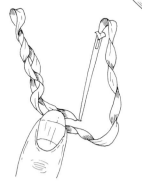

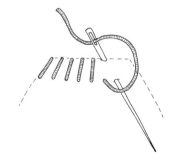
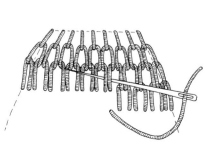

Wave stitch

This is a lovely filling stitch for clothing, giving a lacy appearance. Make the first row of vertical straight/ stab stitches as shown. Then weave the thread in and out of the previous row. Keep an even tension – neither too loose nor too tight. Perlé no 8 or 12 is the best thread for this stitch. To add a ribbed edge use Antwerp stitch (see page 110).

Woven filling stitch

This stitch is ideal for baskets. Use perlé no 8 or 12 threads. Form foundation stitches in straight/stab stitch, or stem- split- or back stitch for larger shapes. Weave the needle in and out of the foundation stitches, as shown. Keep a loose, even tension throughout for a smoother finish.

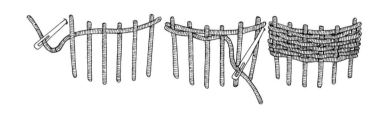

Tassels

To make a tassel, wrap the thread (cotton or silk) around a piece of pre-cut cardboard. The width of the cardboard depends on the length of the tassel you require. Insert a length of thread under one of the wound edges as shown, and tie a secure knot. Cut along the opposite edge. This technique can be used to make ponytails or hair sticking out under a hat as in Bottoms Up..

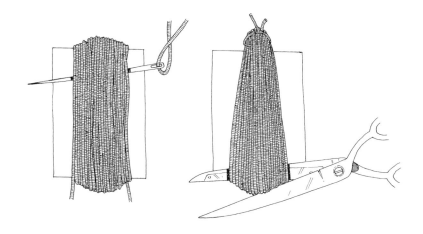

Scroll stitch

This stitch is used to form a ribbed edge. It is worked from left to right. Loop the working thread to the right and then back to the left under the slanted needle.

Split stitch

Split stitch is ideal for outlining shapes. It is usually worked in 2 strands of a stranded cotton or silk. Bring the needle out between the 2 strands as shown.